Barbara Giesen

Ethical Clothing

Barbara Giesen

# Ethical Clothing

New Awareness or Fading Fashion Trend?

VDM Verlag Dr. Müller

# Imprint

Bibliographic information by the German National Library: The German National Library lists this publication at the German National Bibliography; detailed bibliographic information is available on the Internet at http://dnb.d-nb.de.

Any brand names and product names mentioned in this book are subject to trademark, brand or patent protection and are trademarks or registered trademarks of their respective holders. The use of brand names, product names, common names, trade names, product descriptions etc. even without a particular marking in this works is in no way to be construed to mean that such names may be regarded as unrestricted in respect of trademark and brand protection legislation and could thus be used by anyone.

Cover image: www.purestockx.com

Publisher:
VDM Verlag Dr. Müller Aktiengesellschaft & Co. KG, Dudweiler Landstr. 125 a, 66123 Saarbrücken, Germany,
Phone +49 681 9100-698, Fax +49 681 9100-988,
Email: info@vdm-verlag.de

Produced in USA and UK by:
Lightning Source Inc., La Vergne, Tennessee, USA
Lightning Source UK Ltd., Milton Keynes, UK
BookSurge LLC, 5341 Dorchester Road, Suite 16, North Charleston, SC 29418, USA

ISBN: 978-3-8364-9548-6

# Table of Contents

# Table of Abbreviations

| | |
|---|---|
| anon | anonym |
| CFC | chlorofluorocarbons (FCKW) |
| cp. | compare |
| def. | definition |
| e.g. | for example |
| et. al. | et alii (and others) |
| et. seqq. | and the following |
| Fig. | Figure |
| g | gram |
| i.e. | id est (that is) |
| kg | kilogram |
| MJ | megajoul |
| MMF | man-made fibres |
| n.s.c. | not so close to skin |
| n.t.s. | next to skin |
| t | time |
| VAT | value added tax |

## Global Warming, Ready

A young couple, fashionably but barely dressed, is shown on their beach vacation with palm trees and hot weather. The man is rubbing sun lotion onto his girlfriend's back. She seems to be lost in some happy thoughts. Life looks awesome.

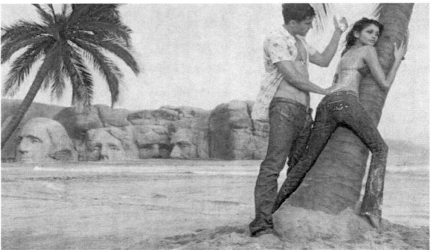

**Fig. 1: Global Warming, Ready - Diesel Campaign 2007**

This could be just an ordinary advertisement for a clothing company, but if one takes a closer look this tropical paradise turns out to be at Mount Rushmore, South Dakota, America. Other photos in this advertising campaign show London submerged in water, Paris as a steamy jungle or a giant desert that is surrounding the Great Wall of China. This is a shocking dystopia, envisioned in the brightest and most vivid colours, picturing a world completely altered by global warming. "Global warming, ready" is the new campaign of the Italian-based clothing company Diesel. It comes at a time when many beauty and fashion companies are either going green or collaborating with green charities and organisations to promote awareness of what we are doing to our planet.

> *"Over the years, Diesel's ad campaigns have touched on several global issues in a signature over-the top, irreverent, often surreal way. 2007 opens with a campaign that highlights the risks awaiting our planet due to global warming. We are only a fashion company and do not think that – with just one campaign – we can save the world, but if our unconventional tone of voice and the reputation of our brand can grab and hold people's attention a little longer than a news feature can, make them think twice about the*

*consequence of all our action and realize our individual responsibility, then something at least will have been accomplished."[1]*

Even being "only a fashion company" comes along with a lot more responsibility and accountability than Diesel claims in the above-mentioned statement. One quarter of all insecticides applied worldwide are used on cotton plants. Added to this, Indian or Latin American women, men and children are working without protective clothing and are poisoned as a consequence of pesticide usage. Furthermore, conventionally grown cotton is a Front-runner in water consumption and leaves whole areas desiccated. Just the fabric for one pair of Jeans swallows around 8,000 litres of water.[2]

## Motivation & Mission

Ethical clothing is the keyword that gives ecology friendly and fair-traded clothes not only a new name, but also a whole new image. The Bio/Eco culture is booming and leaving environmental activists and others with the question; can this be seen as just another fading fashion trend or a change of thinking and a sign of awareness? The motivation of this thesis is to reveal that the topic of ethical clothing has the potential to survive for a longer period of time and might even be considered as a new awareness of consumers and companies.

Trend researchers predict a more sustainable future. Many economists say that there **has to** be a more sustainable future. This awareness has also partly reached the consumers, but they are not able to make well-thought purchasing decisions if there is a constant lack of information. And, it is made even more difficult when governmental regulations confuse more than help. Furthermore, consumers are professionally distracted. Companies spend millions of their budgets on marketing and advertisements to keep focus on their products rather than on the way they are produced. However, this does not imply that consumers are absolved from their responsibility. Social responsibility must be considered as something consumers provide rather than something that is provided to them. Preserving human dignity, promoting social justice and protecting the environment are the greatest challenges facing the global economy. The following chapters explore the question of how much impact the textile industry has on these factors, the state of the art in the textile production, the differences between conventional and ethical clothing and its main pillars.

---

[1] DIESEL; *citation*, [online]
[2] cp. LIEBERMANN, S., *Korrekte Kleidung*

## Work Structure

Ecological production and social balance rightfully achieve a lot of attention these days. But just because public attention had not focused that much on these topics in the past, it does not mean that they did not exist. The first chapter is meant to describe the relation of the textile and clothing sector with the often discussed environmental threats, as well as its historic development against the background of labour issues. This is followed by a brief summary of the Bio-boom, which was the original inspiration for the topic of the thesis. Throughout the research for my thesis, I found it substantial to be able to refer to some basic knowledge about ecological and social aspects. I therefore dedicated the second chapter to the critical ecological and social factors along the whole textile chain of conventional garment production. The second chapter closes with the listing of the major eco-labels, which are designed to provide the consumer with information. Inevitably, the discussion of the problems occurring in conventional production leads to the question of how this could be changed for the better. These alternatives are shown in the third chapter with the example of a pair of jeans. Alternative raw materials and processes are balanced to show alternatives offered from an ethical point of view. The fourth chapter builds upon the framework of the previous chapters to describe and evaluate different visions on how our future and ethical clothing will look like and the place which sustainability will have in this sector.

The final section of my examination is the conclusion. It is formed from the consideration of facts, arguments and evidence of the theoretical part of the thesis, combined with the results drawn from the analysis of the practical part. The outcomes of the individual chapters are reviewed, in order to give a forecast about the position of ethical clothing in the textile market and its future sustainability.

# THE
## ENVIRONMENTAL
# AND
## HISTORICAL
## PERSPECTIVE

1

# 1    The Environmental and Historical Perspective

The beginning of the new millennium became the time for taking stock in many areas of human concern, especially the global environment. A number of surveys had drawn a troubling picture of the state our planet is in. The following four global trends were of major concern:

a.   Population growth and economic development
b.   A decline of vital life-support ecosystems
c.   Global atmospheric changes
d.   A loss of biodiversity[1]

These issues also mirror causes and consequences of the impact, which the conventional textile industry has on our environment. The following chapter is going to look at the significance of this correlation by means of selected examples.

## 1.1    Are Textiles Finishing the Environment?

*a)     Population growth and economic development*

Textiles are one of the basic human needs. A growth in population comes along with the need to be clothed, in industrial countries also the desire for fashionable variations or self-expression. World fibre consumption has increased dramatically since 1984.

Cotton, wool and other natural fibres have been used for thousands of years to make textiles and clothing. Man-made fibres, on the other hand, are an invention of the 20th century. Their commercial breakthrough was started with the successful introduction of nylon stockings in the early 1950's. (cp. Fig. 2, decline of cotton & wool production during that period) Man-made fibres can be further differentiated into natural-, synthetic-, and inorganic man-made fibres. The first generation of man-made fibres is represented by the cellulosic fibres; synthetics are the second, aramids, carbon and ceramic fibres can be regarded as the third generation.[2] By classifying the fibre consumption between natural and man-made fibres one can see that cotton made up the growth in the 80's. The further growth from the 90's until today is due to the increasing demand of man-made fibres, especially Polyester (30%), Polyamid (18%) and Acrylics (17%). In 2005 global fibre production of MMF represented 60%, cotton 38% and wool 2%.[3]

---

[1] WRIGHT, R., T., *Environmental Science*, (p. 3)
[2] cp. EBERLE, H., et. al., *Clothing Technology*, (p. 35)
[3] cp. IVC E.V., *World production*, [online]

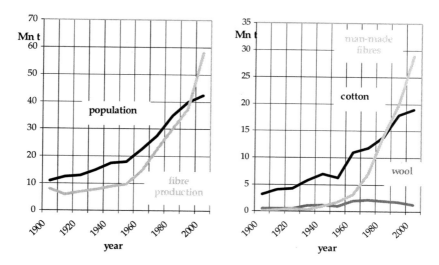

**Fig. 2: World Population & Fibre Production**     **World Production: MMF, Wool, Cotton**

The diagram above clearly shows the large increase in population since 1900. Although the population is growing more slowly than in the recent past, growth remains high. Also high and still steadily rising are the outputs from the textile sector. The demand for apparels, household- and technical textiles, especially in the western countries of the world, have lead to a peak in fibre production. The considerable growth in man-made fibres can be seen as a result of the demand for technical textiles. They are used for protective clothing, in medicine, packaging and engineering, as well as in all forms of transport. Nowadays, technical textiles make up about 30% of the whole textiles production.[1]

Even though the production of the sector is growing in volume, prices and employment in the textile and clothing industry are dropping. Fast fashion claims to improve productivity as well as new technologies and vertically integrated structures.[2] Moreover, an increasing fibre demand comes along with an increasing demand in natural resources, because textiles and fibres are dependent on them throughout the whole textile chain. Energy consumption and the use of toxic chemicals can be considered as the most significant environmental impacts.

---

[1] cp. EBERLE, H., et. al., *Clothing Technology*, (p. 9)
[2] cp. ALLWOOD, M.J., et. al., *Well dressed?*, (p 1)

*b)*     *Decline of vital life-support ecosystems*

Natural ecosystems maintain human life and economies with a selection of goods and services. The fundamental resources of our planet are stressed by the two-folded demand of the increasing population and wealth driven consumption of the individual consumer. These destructive trends have been the subject of the "Pilot Analysis of Global Ecosystems", or PAGE, carried out by the United Nations. PAGE represents the first action in an ongoing project, designed to calculate the long-term impact of human actions on our ecosystems. The study examined the status of the five major ecosystems; coastal/marine systems, freshwater systems, agricultural lands, grasslands and forests. The international group of scientists came to the conclusion that human activities are now beginning to significantly affect the natural cycles on which all ecosystems depend. To quote the report's summary:

*"[…]nearly every measure we use to assess the health of ecosystems tells us we are drawing on them more than ever and degrading them at an accelerating pace."*[1]

The consequences of mismanaging natural resources can be seen with the Aral Sea, an environmental disaster caused by cotton growing. Although being a natural fibre, the crop growing of cotton plants is not as ecology friendly as its image implies. Cotton has the need for large amounts of water, both for cultivation and processing. 550 – 950 litres per square meter are required with an average production of 1,600 kg raw cotton per hectare, or 550 kg lint cotton per hectare. That means, to produce 1 kg of cotton lint, 10,000-17,000 litres of water are needed. The agricultural impacts are catastrophic as well: An approximate area as large as one hundred million hectares (representing 8% of the world's total arable land) is deserted due to former use for intensive cultivation. Although the share is not precisely known, cotton cultivation accompanied with soil salinisation and monocultures are considered the main reason.[2]

The desiccation of the Aral Sea can be seen as one of the largest ecological disasters provoked by mankind. The inland sea in Central Asia lies between Kazakhstan in the north and Karakalpakstan, an autonomous region of Uzbekistan, in the south[3]. Once the fourth largest lake in the world, it is now an ecological disaster area. Between 1960 and 1989 its area decreased by 40%.

---

[1] cp. RICHARD, T., Wright, *Environmental Science*, (p. 4)
[2] cp. KOOISTRA, K, TERMORSHUIZEN, A.; *The sustainability of cotton*, (p.6-8)
[3] WIKIPEDIA, *Aral sea*, [online]

**The Aral Sea through Time**

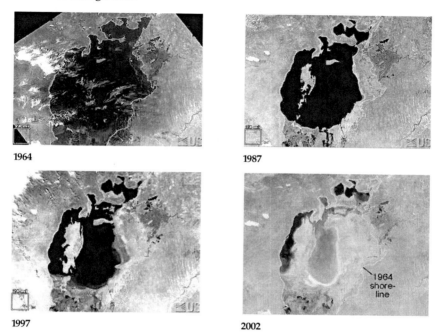

1964                                    1987

1997                                    2002

**Fig. 3: The Aral Sea**

The disappearance of the Aral Sea is predominantly owed to the increasing amount of water withdrawn from two great rivers of central Asia: Uzbekistan's Amur Dar'ya and Kazakhstan's Syr Dar'ya. The massive amounts were mainly used to water the Cotton plants across the region. Only 4 species of fish remain where there used to be 24 and just 38 animal species where there were previously 173. All commercial fishing in the Aral Sea has been lost. There is a deficiency of fresh food because local farmland has deteriorated. The loss of the cooling affect of the Aral has caused the region to heat up. The physical condition of the residents has suffered, with epidemics, soaring cancer rates, increased liver and kidney disease, high rates of infant mortality and birth defects.[1] Finally in 2003 the government of Kazakhstan and the World Bank began taking measures for a restoration project of the Aral Sea. Although scientists predict a recovery, one has to bear in mind that it will never regain its former size and that its rich ecosystems has been lost forever.

---

[1] cp. ANON, *The cotton story,* [online]

*c)*     *Global atmospheric changes*

Besides being a starting material for the manufacturing of man-made fibres, fossil fuel is also the driving mechanism for machines. The textile and clothing sector itself is already very energy intensive, but since globalisation made it able to source, manufacture, dye, print and finish cost-effectively all over the world, transport has become a big issue. An investigation of the Enquete commission for the German government shows the problem of textile transport clearly:

A uniform, consisting of three items, provided the basis for the case study. All three pieces of clothing were made out of a cotton/polyester blend and are comparable to garments worn in every-day life. The analysis showed that semi-finished and finished goods cover huge distances – mainly by motor truck - before arriving in our salesrooms. It is assumed that cotton is supplied from USA and the Polyester manufactured in Germany. Spinning, weaving and finishing is also done in Germany, whereas clothing manufacturing is done in Tunisia. The ready-made garments are then re-imported to Germany. In this case, the goods were transported over a distance of 19,000 km. Approximately 13,800 km via ship, 4,040 km via motor truck and about 1,170 km via train. Energy consumption per kg garment adds up to 4.3 megajoul. (3.6 megajoul equals 1 kWh; in comparison: with 1,194 kWh electrical energy 3 kg of laundry can be dried and ironed)[1]. $CO_2$ – emissions amount to 300 g, round about 30% of the textiles self-weight. Energy consumption for extraction and transport of crude oil, or losses of raw material during man-made fibre production were not taken into consideration.[2] Especially imports of articles from the Far East and Africa relate to the energy consumption of textile and apparel goods. Certain segments of production (e.g. small-scale textile production or apparel assembly) are mainly done in these countries because of low wages and labour. And still, after the consumer use phase the travels of a garment or textile product has not ended. Some clothes and textiles are taken to recycling clothes banks. Most of these items are sorted baled and shipped for resale in Eastern Europe, the Middle East or Africa, adding even more miles and $CO_2$ emissions to their account.

The chart below shows that textile and apparel exports make up more than half of manufacturing exports for a dozen countries, including Honduras, Bangladesh, Mauritius and Sri Lanka. In most of these countries, produced goods are exported to richer countries. Taking the shipping of the raw material, semi-finished and finished goods into consideration, it becomes clear that 19,000 km and more are the standard rather than the exception.

---

[1] cp. ANON, *Was man mit einer kWh machen kann* [online]
[2] cp. ENQUETE KOMISSION, *Schutz des Menschen und der Umwelt* (p 70-71)

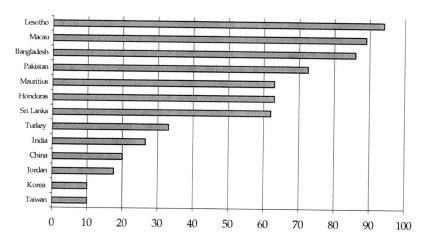

**Fig. 4: Textiles and Apparel Exports as a Percentage of Manufactured Exports, 2001**

*d)      Loss of biodiversity*

*Biodiversity is the variation of taxonomic life forms within a given ecosystem. [...]* The majority of the species extinctions over the last 2000 years are due to human activities, especially the destruction of plant and animal habitats. Increased rates of losses are being driven by human consumption of organic resources. Because an ecosystem decreases in stability as its species vanish, the global ecosystem is going to collapse if it is further reduced in complexity. Factors causing the loss of biodiversity are overpopulation, deforestation, air- and water pollution, soil contamination and global warming or climate change.[1]

At this point the environmental impacts come full circle. The damages attributed to the textile industry that lead to a loss of biodiversity and environmental damages as a whole are big and still increasing. Some factors, like transport, just cannot be avoided. However, they can be minimised to ensure not only sustainable clothing but also a sustainable future.

## 1.2    Historical Perspective of the Textile Industry

Textile manufacturing is one of the oldest industrial sectors in the world. The development of economies and the living standard of people around the world were influenced in important ways by the textile industry.

---

[1] cp. WIKIPEDIA, *Threats of biodiversity*, [online]

Garment and textile production symbolises one industry common to all countries in the global economy. If one looks at the economic and social conditions of the different countries at a given time, you gain an insight into the development and the geographic shifts of the textile sector as it has moved through time and around the globe. As one of the first large-scale economic activities, textile production became the industrial leader that guided the industrialisation process in England. Likewise, definite segments of the industry spread and also introduced industrialisation to most other countries. Stated below are some of the main reasons why the textile sector became a driving force and largely shaped economic and social thought:

- Textile production was the first sector to change from hand labour to the use of hand-powered machines and, later, steam power.
- Technical inventions enabled the textile sector to apply new developments on large scale. As a consequence, England and later the United States were transformed from farming and household economies to ones using factories and mills.
- Mill towns emerged from the establishment of textile factories as working places
- Textile factories were the first systems that allowed women to earn money outside their homes
- Excessive work and poor conditions led to the first industrial reforms. This led to policies protecting workers from abuse by their employers.

The importance of the textile and clothing industry in terms of leadership, as well as the following historic overview are meant to provide awareness of the importance of this sector in global, social and economic evolution. [1]

*The industrial revolution in England*
Prior to the mid-eighteenth century, textile products were a main household manufacture, both for domestic use and on a commercial basis. Social borderlines and affordability allowed only the upper-class to wear foreign materials. Spun yarn, woven cloth, knitted stockings, and lace were the main products. Commercial weaving was often done at home by men, whereas women and girls worked in the household to make products to meet family needs. They mainly used cotton, wool, flax and hemp. Methods of production had changed slowly up to this time. Even though scientific investigations and innovations had occurred in the 1600s, these were not focused on machines or other processes related to production.

---

[1] cp. DICKERSON, K., G., *Textiles and Apparel in the global economy*, (p 28)

But in the late 17th century cotton cloth from India awoke public attention and the English became interested in new products. Capitalists jumped at this opportunity and brought science and capital together to produce new goods. Inspired by the fine Indian cotton fabrics, they sought ways to produce domestic goods beyond the existing household industry. To keep profits in their domestic market, England banned Indian fabrics and developed modern mechanized means of weaving and spinning. Needless to say, the purchase of English cloth grew rapidly as Indian textiles were no longer an option. In addition to domestic use, the cloths were also valued in the slave trade. Early capitalists saw the big prospect and motivated inventors to develop machines to produce the desired goods. Manufacturers began to offer prizes for a machine that would increase production and improve the profitability for British producers. By this time, textile production became more advanced and took a prominent role in broader industrialisation efforts. Therefore, the textile industry, with its series of interrelated mechanical inventions, can be seen as the driving force behind the Industrial Revolution.[1] Having guided the way in changing how goods could be produced, the textile industry provided the groundwork for the transformation of the Western World into a truly international economy. [2]

*Foreign expansion*

During the 1800's and after the elimination of mercantilism, British and other European business leaders began investing in foreign countries. In Asia and other parts of the less-developed world, industry also began to spread, following the industrialisation of the textile sector in Europe and the United States. Textile and apparel industries became the first area for nations to move further than an agrarian society. Economic nationalism emerged in the late 1800's and early 1900's. However, measures were taken to defend markets from imports. One of the first nations to increase tariffs were the United States, as it became a main force in world trade. Generally, trade between nations expanded to a great extent, and a sense of international economic interdependence developed. Shortly after World War II, political institutions and instruments were developed to provide better cooperation and stability. These included the establishment of the International Monetary Fund (IMF) and the General Agreement on Tariffs and Trade (GATT).

---

[1] DICKERSON, K., G., *Textiles and Apparel in the global economy,* (p 31)
[2] cp. BREWARD, C., et. al, *Encyclopaedia of clothing and fashion,* (p 320)

*The late 20th century to present*

Mass production, mass consumption and mass media characterise the twentieth century. In times where self-enhancement and self-expression play an ever-growing role, mass fashion has become a form of popular aesthetics. Progress in technology and materials used for clothing provide a larger proportion of the population with more comfortable, cheaper and more attractive items. No longer manufactured by the company whose label it bears, clothing from large retailers is manufactured through a network of contractors and subcontractors. These circumstances make it hard, but not impossible, to find a clear-cut classification system for the different activities involved.[1] "The textile chain in apparel industry is very complex. That is why it is difficult to pay attention to environmental and social aspects along the way. It took us two years to find solutions for every single step of production." answers Hervé Guétin, cofounder of the French ecolabel Seyes, to the question for the difficulties in the production process of ethical clothing.[2]

*The other side of the coin*

Today, textile companies call themselves "global players" and "global sorcerers". But one man's sorrow is another man's joy; labour issues are central to much of the global restructuring that has occurred in the textile and apparel industries. Nearly 55% of textiles clothes offered in Germany are assembled in low-wage-countries. Except for high-technology textile production, the question of where and how products are made is associated with labour issues, particularly the availability and cost of labour. The president of the North-Rhein-Westphalia Textile Industry Association was asked what the ideal textile company would look like in the year 2000. He put it this way:

*"The ideal textile company is built on a ship. It stops where wages are at their lowest!"[3]*

Unfortunately, poor pay checks are not the only problem that textile workers in these countries have to deal with. The wish to form an association (or trade union) to declare their rights or to demand appropriate working conditions, training and promotion is denied by subcontractors. In some countries it is still common practice to use repeated temporary contracts. Even worse, the absence of any employment contract combined with the delayed payment and the lack of employment benefits. Also child labour and sexual harassment (physical or sexual abuse) can be regarded as major problems of social implications.[4]

---

[1] cp. BREWARD, C., et. al, *Encyclopaedia of clothing and fashion*, (p 318 - 319)
[2] cp. KERN, J., Socialwear: *Das Interesse wächst*
[3] cp. BALZER, M., *Gerechte Kleidung*, (p 19)
[4] cp. ALLWOOD, M.J., et. al., *Well dressed?*, (p 16)

## 1.3    Bio Boom – Sustainable Products for the Mass Market

It is everywhere you look and shop: in supermarkets, drugstores and perfumeries – Bio/Eco booms. The German population alone spent over 4 billion Euros on so-called "bio/eco-products" last year.[1] Forerunners in this sector are the wholefood products. As shown in the following table, a steady increase in turnover can be documented since 2001. That means a growth in sales volume by 66% within a period of five years. Similar figures have been reached in the cosmetic market, giving a positive outlook for the textile branch.

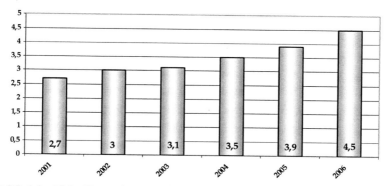

**Fig. 5: Wholefood Sales Figures for the German Market [Turnover in Billions]**

Just about ten year ago doing good and making money seemed to be impossible: Companies like AlbNatura and Panda declared bankruptcy, Britta Steilmann and even big chains such as H&M stopped their eco-lines. But nowadays, ecological idealism and economic success do not necessarily contradict one another. This is shown by the mail-order company "Hess-Natur", a subsidiary of Neckermann and part of KarstadQuelle. Revenue in 2005 grew by 6% up to 56 million Euros, a new flagship-store was opened in 2006 with a retail area of 9500m² and the "modern women collection" started in 2007 to meet expectations of a younger target group.[2] "Sustainable trade is already suitable for the mass market" says Prof. H. Merkel, management board member of KarstadtQuelle. "The number of labels with ecological and ethical orientation is steadily increasing. This shows that demand for ethical fashion brands with fair manufacturing conditions and ecological raw materials is growing. The customer takes influence on changing something and assumes responsibility by making a deliberate purchase decision. This also includes the demand for products of companies that combine fashion with ethics."[3] For years

---

[1] cp. BOCK, C., *Hinter den Kulissen der Öko-Branche*, [online]
[2] cp. KERN, J., *Die Staubschicht wird abgepustet*
[3] cp. PIATSCHECK, N., *Wann wird Fair Fashion massentauglich?*

there were scandals showing consumers that clothing companies are not really ecological and ethical leaders. Due to the activities of governments and non-governmental organisations a lot has become public. People were affected personally by the mad cow disease or bird flu. The sensitisation seems to have had an impact other consumer goods, like clothing.

But still, look and price/performance ratio have priority when it comes to buying garments. Two-thirds (65%) of the consumers polled declared that it does not matter to them how or where a piece of clothing is produced. They mainly focus on liking/taste and an adequate price. On the other hand, there already is a large number of people who want to know more about social and ecological aspects. After all, one out of ten claimed to generally attach importance to these matters.[1] Fortunately the point of green fashion products in the 21st century is that the consumer no longer has to choose. Labels like American Apparel, Kuyichi, Edun, Stewart Brown, Noir and Misericordia are gaining more and more followers, offering stylish clothing and environmental awareness. However, chic design and an ethical claim alone do not make the sale – a trend is needed. These days, you can hardly find one Hollywood star who is not involved in an environmental project or who exposes their conscious lifestyle. According to the "Gala"-magazine, Cameron Diaz and Cate Blanchett wear ethical clothes and "Vanity fair" just published a green edition. There even exists an Internet site called "ecorazzi – the latest in green gossip", to inform readers about ecology related boulevard. More and more people follow the example of celebrities. Today, environmentalism and social commitment is trendy and glamorous.

"The ecological movement has changed a lot. In the past, people solidarised and tried to make a change together. Today you just go out and buy a T-shirt from American Apparel. Ecology management is therefore not based on an ideological philosophy of life, but is closely related to personal benefit. […] Consumers expect that companies also create an environmentally friendly product. […] They become more and more aware of the power they hold and want to be an active part [within the new ecological movement]. Environmentally conscious behaviour comes without abandonment or the joining of an organisation", says Prof. Peter Wippermann, trend researcher and director of "Trendbüro" in Hamburg.[2] An online survey of Dialego in October 2005 about the motivation of people to buy wholefood products underlines Prof. Wippermann's statement. It is not about helping regional farmers or minimising usage of pesticides, but mainly for one's own comfort. Half of the people interviewed said, that the main reason for them to buy

---

[1] cp PIATSCHECK, N., et. al., *TW Kundenmonitor Socialwear 2006*, [online]
[2] cp SEITH, A., *Sex,Drugs and Bio-Slips*, [online]

eco-food is because it is healthy and forty percent stated that it tastes better.[1] The more social and individual benefits are paired, the more likely the consumer is to buy an environmentally friendly product. And at the end of the day, buying ecological and fair traded products benefits all, consumers and the whole society – both today and in the future.

Regardless of the motivation people have to buy ethical products, the figures and prognoses show a clear trend towards sustainability. The successful product of the future is not just of good quality, but communicates an added moral value.

---

[1] cp. PIATSCHECK, N., et. al. *TW Kundenmonitor Socialwear 2006,* [online]

**Fair & Stylish Fashion
for Everyone**

Fig. 6: Hess-Natur [online]

Fig. 7: Kuyichi [online]

Fig. 8: American Apparel [online]

# ECOLOGICAL & SOCIAL ASPECTS IN THE TEXTILE AND CLOTHING INDUSTRY

2

## 2 Ecological and Social Aspects in the Textile and Clothing Industry

Consumers are becoming more and more aware of the fact that conventional production creates a great ecological and social burden along the whole textile chain. This leads to an increasing demand and supply of eco-textiles and can be seen as an important development in the textile and clothing market. Consumers are given the opportunity to behave in an environmentally friendly manner without having to make significant sacrifices in terms of price, quality or comfort.

### 2.1 Definition of the Term "Sustainability"

*"[Sustainable development] meets the needs of the present without compromising the ability of future generations to meet their own needs"[1]*

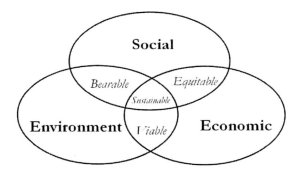

**Fig. 9: Sustainable Development**

The term ethical clothing is based on the principles of sustainability. It relates to the continuity of ecological and social aspects of human society. Targets for sustainable clothing are at different levels. Few successful producers of ethical clothing combine and compromise social, environmental and economic aspects. Lower profit margins are accepted for the benefit of higher wages and high fashion products are substituted by more classic designs in favour of limitations due to natural based raw materials. Conversely, uncompromising positions are loosened, accepting synthetic fibres for particular purposes and realising that fashion trends cannot be totally neglected if one is to survive on the market. Even the company Hess-Natur, which is considered to be a role model, had to admit to a percentage of a maximum of 8% Spandex in their underwear collection to increase wearing comfort and functionality.

---

[1] WIKIPEDIA, *Sustainability*, [online]

With seven per cent of total world exports, the clothing and textile sector represents an important part of world trade.[1] Nevertheless its rapid growth in the past few years, ethical fashion still represents a minority in this sector. The conventional textile and clothing industry is a diverse one, as much in the raw material it uses as the techniques it employs. Every production step is coupled to the input of numerous chemicals and auxiliary materials, high-energy use and wastewater loads. That means textile production, in its recent form, is heavily affected by social and ecological aspects of sustainability.

## 2.2 Ecological Problems

Because of the volume of the sector, the textile and clothing industry is often subject to ecological interest. In the beginning of the nineties the Enquete Commission of the German Bundestag carried out a study about sustainable cycles of matter and material flows in industrial society. The commission assessed in their report the major ecological weak spots along the textile chain.

### The Textile Chain and its Outcomes

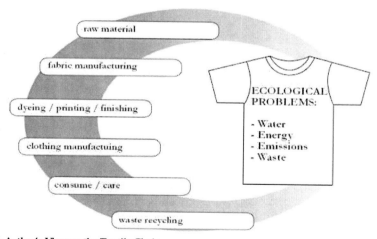

Fig. 10: Author's View on the Textile Chain

To give the reader an overview, the main ecological threats are at first summed up in note form. They are then summarised under four topics, which are explained in detail. The topics discussed can just be seen as an abstract and, therefore may not present a complete picture.

---

[1] cp. ALLWOOD, M.J., et. al., *Well dressed?*, (p 8)

*Natural fibres:*

- Broad usage of landscapes for agriculture and crop cultivation
- Extinction of species from pasture and crop growing areas
- High quantities of $N_2O$ emissions due to cotton cultivation
- Use of herbicides, pesticides and defoliants
- Continuous development and usage of new agents as a result of development of resistance
- Treatment of natural fibres with conserving agents for transport and storage
- High water consumption
- Usage of fertilizers (soil nitrification)
- Consumption of non-renewable resources for transport of products and other facilities

*Chemical fibres:*

- Excessive usage of non regenerative resources as raw materials and processing heat
- Emissions from the manufacturing of synthetic fibres
- Utilisation of catalysers containing heavy metals
- High loads of waste water

*Finishing:*

- Emissions, water pollution and high degree of waste
- Energy consumption during production process
- Decomposition of sizing materials and dyestuffs under aerobic conditions

*Consume/ Care:*

- Usage of eco-toxic substances for cleaning
- Consumption of non-renewable resources for aftercare

*Disposal:*

- Poor degradation performance of certain fibres
- Lack of knowledge regarding processes of textile chemicals on waste sites[1]

---

[1] cp. ENQUETE KOMISSION, *Schutz des Menschen und der Umwelt* (p 71)

*Transport:*

- High $CO_2$ emissions
- Consumption of non-renewable resources
- Usage of conserving agents for transport
- Water pollution due to oil transports [1]

## 2.2.1   Wastewater

Extensive amounts of water are consumed during many processes of textile operations: Water baths provide the application basis of nearly all dyes, especially chemicals and finishing agents. Also most preparation steps like desizing, scouring, bleaching and mercerizing use aqueous systems. However, the total quantity of water use varies widely in the industry. Management philosophy, specific processes and the kind of applied equipment make a great influence on water consumption. Measures for pollution prevention make the reduction of water usage crucial, because excess water consumption dilutes pollutants and adds to the effluent load.[2] But not only the quantity of water use varies, but also the kind and degree of pollution. A uniform evaluation is therefore not possible. Regional differences regarding fibres, processing, apparatuses and desired performances of the endproduct exist. In the following, impacts associated with wastewater are described, always considering that there is no typical textile wastewater.

*pH-value*

The pH-value of an environment is very sensitive. In order to function properly, organisms are capable of adjusting their internal pH. But, because enzymes, hormones and other proteins in the bodies of all organisms are affected by the pH-value, even slight changes can be critical. Low pH values indicate increasing acidity, while high pH values indicate increasing alkalinity. A consistently low value often overextends the regulatory mechanisms of aquatic life forms, weakening or killing them. The pH of wastewater needs to remain between 6 and 8 to protect organisms. Many organisms already die if the environmental pH value is altered by as little as one from the optimum level. Low pH water can also dissolve compounds in the soil and free bounded metals. If these metals may then be absorbed, they become highly toxic to vegetation and animals. For example, some great lakes have such high mercury levels that government advise against eating fish caught in those waters.[3]

---

[1] cp. ENQUETE KOMISSION, *Schutz des Menschen und der Umwelt* (p 72)
[2] cp. NCDENR, *Water efficiency* (p 1) [online]
[3] WRIGHT, R., T., *Environmental Science* (p 591)

*Nitrogen*

The presence of nitrogen in wastewater discharge can have a great impact on the ecology. Within the textile sector, it can be found in Azo dyes and fertilisers for agriculture. As plants have a high need for nitrogen, additions of nitrogen compounds encourage plant growth and might lead to eutrophication. Nitrogen is a common limiting factor in coastal marine waters. That means it controls processes, like organism growth. If nitrogen is abundant, it promotes the dense growth of phytoplankton. This in turn increases turbidity and leads to the death of other aquatic vegetation. Dead algae sink to the bottom of the ocean. There, they are decomposed by oxygen-consuming bacteria, which results in their explosive growth. The bacteria consume most of the surrounding waterborne oxygen; as a consequence little oxygen is left for the other life-forms that depend on it.[1]

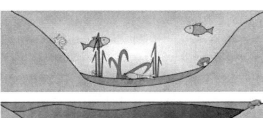

OLIGOTROPHIC

- Clear Water
- Light penetrates
- Low in nutrients
- Phytoplankton limited

NUTRIENT INPUTS

- Turbid Water
- Aquatic vegetation shaded out
- Nutrient rich
- Phytoplankton thrives

EUTROPHIC

- Fish and shellfish suffocate
- Nutrient rich
- Rapid turnover of phytoplankton
- Accumulation of detritus and
  dead algae

**Fig. 11: Eutrophication**

A famous example for the impact of agriculture fertilisers is the dead zone in the Gulf of Mexico. In 1974 the hypoxic area or so-called "dead zone" was discovered. Scientists first thought it was a minor disturbance that would appear seasonally, like with other bodies of water. Since this time the area has doubled in size and can span 13,000 – 21,000 square kilometres wide at its peak. This is about the size of New Jersey and it continues to grow. Agricultural fertilisers have been

---

[1] cp. WIKIPEDIA, *Eutrophication* [online]

identified as the main reason behind this phenomenon.[1] One has to keep in mind that the USA is amongst the seven largest producers of cotton in the world, Texas being the American leader in total production.[2] That means that also fertilisers of cotton agriculture contributed to this ecological disaster.

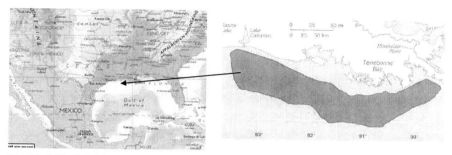

Fig. 12: Gulf of Mexico          Fig. 13: The Dead Zone in the Gulf of Mexico

*Heavy metals*

Compounds of heavy metals have brilliant colours and are therefore often used for paint pigments, ink and dyes. Heavy metals are found for example in metal complex dyes, in the form of Chromium-, Cobalt-, Copper- and Nickel compounds. They are mainly used for wool, silk and nylon dying. Due to their large size and low solubility of the complex dye molecule, they have good fastness properties, which cannot often be reached with metal-free dyestuffs. Copper increases lightfastness or is used to reach the desired shade of colour. Also the colourfastness of blue and turquoise in cotton dying with reactive dyes is significantly enhanced by Copper and Nickel. How many heavy metals enter the environment through wastewater very much depends on the fixation rate during the dying process. Nevertheless, they represent a big environmental hazard. Copper, Chromium, Cobalt and Nickel concentrate in sewage sludge and become problematic because they cannot be degraded. If not treated, they pollute water, soil & organisms and concentrate in the food chain.[3]

*AOX – absorbable organic halogens*

Toxic and lowly biodegradable halogenated organic compounds are toxic and can pollute water for years. Sources in textile production are mainly bleaching processes with Chlorine, soluble dyes and insoluble pigments. The AOX is not a substance class but an indicator and analytical method for determining the amount of absorbable organic halogens. (In chemistry X stands for the

[1] cp. NATIONAL GEOGRAPHIC, *Gulf of Mexico "Dead Zone" is size of New Jersey*, [online]
[2] cp. WIKIPEDIA, *Cotton*, [online]
[3] cp. BALZER, M., *Gerechte Kleidung – Fashion Öko Fair; Ein Handbuch für Verbraucher* (p 193 - 194)

Halogens Fluorine, Chlorine, Bromine and Iodine) Chlorine is still an essential component of dyes, and until today there is no substitute for it. But measures have already been taken to reduce AOX formation and toxicity. Also current research gives the outlook that AOX-free methods will be developed in the near future. [1]

*BOD – biochemical oxygen demand*

Textile wastewater can contain a high organic pollution load. Emissions of volatile organic compounds mainly arise form textile finishing, drying processes and solvent use. The BOD is an indicator of the amount of organic material in a sample of water. It gives information about how much oxygen will be needed to break it down biologically or chemically. Textile wastewater tends to have a high BOD varying from 700 to 2,000 milligrams per litre (mg/l). The higher the BOD, the greater the possibility is that dissolved oxygen is used up during the breaking up process. A high BOD can lead to so much oxygen depletion that animal life is limited or becomes extinct, which is occuring in the bottom waters of the Gulf of Mexico. [2]

### 2.2.2 Energy

The consumption of non-renewable energy resources is considered a great problem in the textile industry. Particularly transport and finishing, but also the production of man-made fibres, account for the ecological imbalance. Energy consumption by itself is not the problem, but the extensive usage of non-renewable resources.

*Energy sources*

Oil, coal, gas, nuclear, and renewable sources meet the world's energy demands:

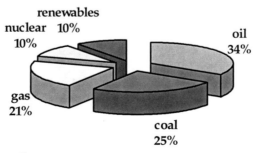

**Fig. 14: Primary Energy Sources**

---

[1] cp. BALZER, M., *Gerechte Kleidung – Fashion Öko Fair; Ein Handbuch für Verbraucher* (p 193 - 194
[2] cp. WORLD BANK GROUP, *Pollution Prevention and Abatement Handbook* (p 408)

From the human point of view, oil, coal and gas are non-renewable resources. Together they cover approximately 80% of the demand for energy, whereas renewable energy sources like tidal energy, hydroelectric power, wind power, solar energy and geothermal energy only add up to a mutual share of 10%.

*Primary production, natural fibres*

In primary production of natural fibres, the consumption of non-renewable energy is highly dependent on the location and degree of mechanisation. For the production of 1 kg cotton the following energy demand arises in the different growing areas.

| | | |
|---|---|---|
| USA | 41.87 MJ | |
| GUS | 41.87 MJ | For illustration: 41.87 MJ correspond |
| Australia | 41.87 MJ | to approximately 1kg raw oil |
| Sudan | 12.56 to 20.94 MJ | |

Besides the energy consumption for transport and machinery, resources are also used for production and distribution of pesticides.

*Primary production, man-made fibres*

The basis for synthetic fibres are petrochemical raw materials, i.e. non-renewable resources. This is important regarding the realisation of the approach towards a sustainable development in textile production. In addition to raw oil as the basis for MMF, it is also used along with coal and gas as an energy source during the production process. [1]

*Transport*

The relevance of transport within the textile chain has increased significantly during the past decades. As previously described (cp. chapter 1.1 *global atmospheric changes*) clothes can easily travel a distance of 19,000 kilometres before arriving in our shops. International division of work and global trade justify transportation of raw materials, semi-finished and finished products. Also the increasing distances between areas where natural fibres are grown and markets add to the increase in transportation. Furthermore, exploration, production and transport of the resources themselves have to be considered in terms of ecological consequences: e.g. marine pollution during oil production on the high sea or impacts on sensitive ecosystems like Siberia, Alaska or the domestic Wadden Sea.

---

[1] cp. ENQUETE KOMISSION, *Schutz des Menschen und der Umwelt* (p 59 et. seqq.)

*Finishing*

During the production of finishing agents, primary energy sources are oil, gas and coal; secondary sources are water, steam, ice and electricity. This sector makes up around 7% of the manufacturing costs. As mentioned before, the energy consumption during finishing is extremely high. It increases from finishing of yarns to finishing of knitted goods, and yet again to finishing of fabrics. For preparation, dying, printing and finishing, natural fibres take up about 10 to 20 MJ per kg. Man-made fibres need just half of the energy consumption of natural fibres.

*Energy outlook*

The term non-renewable implies two energy related threats that not only face the textile and clothing sector. On the one hand, adequate and secure supplies cannot be granted for more than another hundred years and, on the other hand, exaggerative consumption generates environmental harms. If nothing changes, severe and irreversible environmental damage will be caused. Sustainability in the textile and clothing industry can be greatly enhanced by improved technologies. Energy saving means of transport, for example, have to be greatly supported. Application processes for permit of new manufacturing facilities have to be accelerated in favour of better implementation of environmental friendly equipment. Energy is an aspect that is unfortunately often paid little attention. But the consumption of energy and resources in fibre production can be reduced by integrated environmental protection. Actions have to be taken on a global basis, because international adjustment of standards is the framework for substantial progress. [1]

### 2.2.3 Emissions

*(In this context emissions are seen as the discharge of airborne pollutants)*

Within the last millions of years, the earth has built up an equilibrium of different gases. Pure air consists of 78.09% Nitrogen, 20.94% Oxygen, 0.93% Argon and 0.03% Carbon dioxide. Mankind has changed this atmospheric composition by industrial and agricultural activities. We doubled the concentration of methane and increased the concentration of Carbon Dioxide in the atmosphere by 26%. Our natural defence against ultraviolet radiation is depleted by the production of Chlorofluorocarbons and pollution also affected the quality of air.[2] In 1974 the German Bundes-Immissionsschutzgesetz (BImSchG) came into force, to protect humans, animals, plants and real assets from dangerous environmental hazards. It includes a technical

[1] cp. ENQUETE KOMISSION, *Schutz des Menschen und der Umwelt* (p 101 et. seqq.)
[2] cp. ROUETTE, H.,K., et. al., *Grundlagen der Textilveredlung* (p 876 – 877)

manual for air pollution prevention. It describes state of the art technology for the reduction of airborne emissions for more than 40 industrial installations. 50 suspended particles and 120 gaseous pollutants are divided into three classes regarding their environmental impact and limiting values are estimated for the most hazardous substances like Chlorine- and Fluorine-compounds. Furthermore protection laws for maximum workplace concentration and maximum immission concentration are outlined.

## 2.2.3.1 Protection Laws
*MAK*

The "maximum workplace concentration" describes the concentration limit of immissions at breathing height. It defines the reasonable level to which a worker can be exposed without adverse health effects, working shifts of eight hours per day and maximum 40 to 42 hours per week were taken into consideration.

MIK

The "maximum immission concentration" limits the concentrations present in layers of the free atmosphere near the ground.

Within a distinctive volume of exhaust emissions, the concentration can be measured. The data is recorded as Mass concentration in $mg/m^3$ or as Volume concentration in $cm^3/m^3$ = ppm (parts per million). [1]

## 2.2.3.2 Impact of Emissions on the Environment and Workers
Emissions resulting from textile production originate mostly from the following sources:

- Production of process steam: to fulfil their energy demand most mills have their own machines for generating heat and electricity; the related combustion plants work with petroleum or natural gas.
- The usage of a stenter frame is common after the padding application of chemicals in textile processing. (preceding processes can be: singeing, thermofixing, thermosoling, impregnating and functional finishing.
- Coating, impregnating and finishing processes using solvents for chemical application.
- Regarding the actual state of awareness, no relevant airborne emissions seem to come from the pre-treatment and dying processes.[2]

---

[1] cp. ROUETTE, H.,K., et. al., *Grundlagen der Textilveredlung* (p 877)
[2] cp. LACASSE, K., et.al., *Textile Chemicals – Environmental Data and Facts* (p 485)

The impacts of air pollution are a matter of common knowledge. One phenomenon, for example, is the greenhouse effect. It arises through the increase in gases in the atmosphere that reflect light. This leads to higher temperatures and contributes to global warming.

Along with noise and one-sided physical strain, fugitive emissions are the main reasons for occupational illnesses. Diseases from asbestos usage like asbestosis, lung cancer and mesothelioma still exist as long-term consequences for textile workers. In the past, Asbestos was used in spinning and weaving departments for the manufacturing of textile products. (gloves, protective clothing etc.) The diagram below shows the ten most frequently acknowledged occupational diseases in the textile, clothing and leather industries. The largest share are noise and asbestos related diseases, followed by skin irritations and allergic diseases of the respiratory path; diseases that are generally be related to air emissions are highlighted in red.[1]

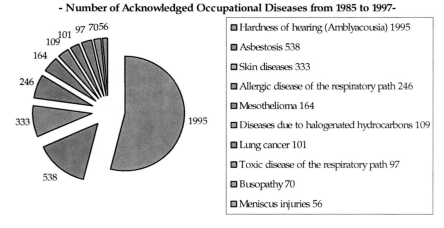

- Number of Acknowledged Occupational Diseases from 1985 to 1997-

- Hardness of hearing (Amblyacousia) 1995
- Asbestosis 538
- Skin diseases 333
- Allergic disease of the respiratory path 246
- Mesothelioma 164
- Diseases due to halogenated hydrocarbons 109
- Lung cancer 101
- Toxic disease of the respiratory path 97
- Busopathy 70
- Meniscus injuries 56

**Fig. 15: The Most Frequent Occupational Diseases in Textile, Clothing and Leather Industries**

### 2.2.4 Waste

In sustainable development, textile recycling and the contribution that textiles make to the waste stream have a significant impact. Solid wastes arise from yarn and fabric manufacturing, garment making processes and from the retail industry, although the majority of textile waste originates from household sources. Textile use in Germany results in a total of 28 kg per head, placing us amongst the countries with the highest textile consumption.

---

[1] cp. BALZER, M., *Gerechte Kleidung – Fashion Öko Fair; Ein Handbuch für Verbraucher* (p 65)

This amounts to an overall availability of 1.9t in Germany per year. Over time, this quantity will be subject to disposal and recycling. But also in textile recycling, certain environmental aspects have to be considered. Since 1996, the German Recycling- and Waste Management Law (Kreislaufswirtschafts- und Abfallgesetz) forms the legal framework to minder impacts generated by textiles and clothing. As the name implies, governmental work focuses on the lifecycle of the garment, prioritising an after use of the material. Textiles should not be thrown away after a single use phase, but should be led back into a second usage or production cycle.[1]

Out of 1.9t of material about 50% is further used or processed. There is a good demand in the industry for production waste, as it is cleaned and the composition of the blend is exactly known. The German Association for secondary raw material and disposal (Bundesverband für Sekundärrohstoffe und Entsorung e.V) published the following figures dividing up the different uses of textile household waste in Germany:

| | | |
|---|---|---|
| Second hand clothing | 50% | 310,000t |
| Cleaning cloth | 17% | 106,000t |
| Reprocessed material | 21% | 130,000t |
| Waste | 12% | 74,000t[2] |

### 2.2.4.1 T-shirts in the Afterlife

Like any other industry, the textile recycling sector also comes with a list of advantages and disadvantages. Advantages for recycling include, for example, the saving of textile resources, the generation of recycled products out of textiles, the avoidance of waste, the usage of revenues for charity, the creation of new workplaces and securing of existing ones. One big problem, on the other hand, is the recycling itself. Foreign clothing is often produced with disregard to ecological criteria. Unknown blends of raw materials, questionably finishing agents or toxic auxiliaries that are prohibited in German production can be included and lead to unknown complications. Tons of clothing has to be recycled ecologically, whereas input is provided from foreign materials, which are produced regardless of any ecological considerations.

Also the question whether it can be seen as ethical to ship bales of western countries' cast off T-shirts into third world countries generates sharply conflicting views about global trade. Is it a dirty business to exploit the goodwill of charities and to suffocate the developing countries with

---

[1] cp. INKOTA NETZWERK e.V., *Logo or no Logo* [online]
[2] BUNDESVERBAND SEKUNDÄRROHSTOFFE & ENTSORGUNG, *Textilrecycling* [online]

used clothes? Or is it a great gesture and the benefits of free market dynamism that channels charitable impulses into clothing for the poor?

## The Changing Face of Used Clothing

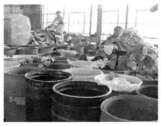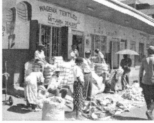

Fig. 16: Sorting Business          Fig. 17: Mitumba Market          Fig. 18: PANOS

Compensating for deficiencies in the supply was the main reason for collecting textiles during the immediate post World War II years. In this time hardly any used clothes were left, as people tried to substitute the lack of primary raw materials with textile materials during the Second World War. A new development started in the sixties. The newly acquired wealth led to a change in consumer behaviour. Clothes were not worn out anymore but replaced before they fell apart. The industry changed completely; today recycling has to be done in order to prevent the western countries to be buried under a mountain of Textiles. About half of the clothing thrown away in Germany has another life to live. Over 70% of the world's population uses second-hand clothing.[1] Where we see waste, the rest of the world sees perfectly fine clothing. "Clothing of the dead white man" or "mitumba" name Africans imports of textiles. But more and more countries nowadays ban the import of used clothing. This has been provoked mainly by a call from the local textile industries in order to protect their markets from competition. Just like the American industry was threatened by Chinese T-shirts in 2004, or the British industry was threatened by Indian cotton imports in 1720. [2]

---

[1] TEXTILES ON LINE, *Library* [online]
[2] RIVOLI, P., *The travels of a T-shirt in the global economy* (p 177)

## 2.3    Social Aspects

The expansion towards a global economy comes hand in hand with a lot of opportunities and possibilities. But, is the global village really the basis for development or does it turn out to be a false pretence to establish social imbalance? Globalization as such is not a bad thing, but it falls short in offering advantages for the not so privileged countries. The macro-economic global village can be depicted as if it were a global supermarket: cheap raw materials from China are stored in the refrigerated section, on the rummage table there is a special offer for Thai workers and scientists & designers can be found in the delicatessen shelves right next to clever marketing people inventing new sales strategies.[1] In the last thirty years the textile and clothing industry has become a travelling circus, i.e. locating production wherever it is at its cheapest. The sector does create jobs, but there are still many concerns about the quality of these jobs and their social consequences.

- Children: Up to this time, the elimination of child labour remains a challenge in the clothing and textiles industry. The difficulty is the monitoring of subcontractors, indirect workers and home workers.
- Women: Mainly young "low-skilled" or "unskilled" women represent the workforce in this industry. They are helpless to various forms of abuse and simply do not know how to claim their rights as workers.
- Sexual harassment: Many women are threatened by their superiors and are unable to complain for fear of losing their jobs.
- Pay: It is common practice that workers cannot live on their wages, although they are working around 60 to 80 hours a week, longer hours are enforced and not paid for. Countries have legally defined minimum wages, but there is a huge difference between the minimum wages, which are legal under national employment law, and the minimum wages, which are truly needed to pay for local living costs.[2]

### 2.3.1    Child Labour

Child labour is often thought of as a past evil that has now been eliminated. The truth is that, millions of children throughout the world still work in conditions as horrific as the factories 150 years ago. These children are robbed of their childhood, working 18 hours a day, seven days a week. Fortunately awareness is rising and the International Labour Office states that an end to

---

[1] cp. WEISS, H., et. al., *Das neue Schwarzbuch Markenfirmen* (p 37)
[2] cp. ALLWOOD, M.J., et. al., *Well dressed?*, (p 1)

child labour might be within reach. The most recent major event, which has aroused public interest, occurred when the American Magazine "Life" published photos in 1996, showing children sewing footballs with Nike's swoosh-logo.

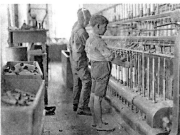  

Fig. 19: Child Labour during the  Fig. 20: Child working for  Fig. 21: Demonstration
        Industrial Revolution                 Nike in 1996              Child Labour,
                                                                          1997

Little is know to which extent children's health and safety is affected by their working time. The International Programme on the Elimination of Child Labour (IPEC) published a working paper on working time and health. Government surveys of data from Bangladesh, Brazil and Cambodia reveal an understanding of the relationship between working time, conditions of work and health outcomes. The results show that a significant causal connection exists; the probability of suffering from work-related ill health or injury adds up with each additional weekly hour of work. Instead of increasing the gap between the poor and the rich, Globalization and the resulting economic development could actually lead to a reduction in poverty and child labour. This could be the case if expansion efforts focus on the reduction of poverty rather than provoking it and taking advantage of people's needs. If essential education is progressively extended instead of letting under-aged children work for consumer goods from western countries and if government agencies, employers, trade unions and others combine forces to implement laws for a minimum age for employment and create opportunities for children, then the trap of premature work can be avoided.[1]

## 2.3.2 Fashion Victims

Before 1830, clothing was mainly produced by male-members of the organised tailor's guild. It had been a luxurious custom item. As the Industrial Revolution led to higher volumes of inexpensive clothing, members of the tailor's guild were replaced with lower-skilled workers. The introduction of the foot-powered sewing machine in 1846 also accelerated this trend. So called "sweatshops" became common practice. That means, a specific type of workshop in which a middleman directed others in garment making. The middleman or "Sweater" kept workers

[1] cp. INTERN. LABOUR OFFICE GENEVA, *The end of child labour: within reach* (p 32), [online]

isolated in small workshops. They became insecure regarding their supply of work and were not capable of standing up for their rights through collective bargaining. Profits were increased by finding the most desperate labourers, often women and children.[1] Over 150 years later sweatshops still exist in the world today. Although trade unions, labour laws, fire safety codes and minimum wage laws made them less common in the developed world, they did not eliminate them. Nowadays the term has come to be more and more connected with factories in the developing world. Young women make up 90% of sweatshop labourers. They are often encouraged by their families to leave school to work in the garment industry, while higher value is placed on male education. As arriving in a new community away from home, they have to spend a larger amount of income on supporting themselves. Working ten to twelve hour shifts, women are paid just a few cents per hour. Often overtime is mandatory. Cases are known, in which drinks are sanctioned down to two per shift and bathroom breaks are not allowed without admission of the foreman. To keep the workforce in line, sexual harassment, corporal punishment and verbal abuse are used by supervisors. [2]

> *"I began as a shirt-waist maker in this shop five years ago. For the first three weeks I got nothing, though I had already worked on a machine in Russia. Then the boss paid me three dollars a week. Now, after five years' experience and I am considered a good worker, I am paid nine. But I never get the nine dollars. There are always `charges' against me. If I laugh, or cry, or speak to a girl during work hours, I am fined ten cents for each 'crime.' Five cents is taken from my pay every week to pay for benzine which is used to clean waists that have been soiled in the making, and even if I have not soiled a waist in a year, I must pay the five cents just the same. If I lose a little piece of lining, that possibly is worth two cents, I am charged ten cents for the goods and five cents for losing it. If I am one minute late, I am fined one cent, though I get only fifteen cents an hour; and if I am five minutes late, I lose half a day's pay. Each of these things seems small, I know, but when you only earn ninety dimes a week, and are fined for this and fined for that, why, a lot of them are missing when pay day comes, and you know what it means when your money is the only regular money that comes in a family of eight."[3]*

The story of a Russian girl working in the garment industry is the same as for many other young women. At the end of the day, the wellbeing and safety of women garment workers depend on government accountability. Labour laws and standards have to be enforced, increasing women's opportunities for education and political participation, and ending violence against women.

---

[1] cp. WIKEPEDIA, *Sweatshop*, [online]
[2] cp. FEMINISTS AGAINST SWEATSHOPS, [online]
[3] FINN SCOTT, M., *The spirit of the girl strikers*, [online]

### 2.3.3 Who Pays for Cheap Clothes?

Costs largely determine the industry's choice and location of suppliers. In a number of Asian, African and Eastern European countries labour costs are as low as 0.5% of the retail price. Relocating to regions where labour is cheaper and where regulations go un-enforced keep the prices down. Moreover, subcontracting to smaller production units and homeworkers who are paid less than factory workers is a crucial factor in tightening the price spiral. A number of semi-regulated or unregulated sweatshops are included in the European supply chain. Overseas, the same process has led to results so complex that retailers at the top of the pyramid often have little idea where – and under what conditions – their clothes were/are actually made.[1] Rosey Hurst, director of supply chain consultancy Impactt. agrees:

*"Buyers pressure factories to deliver quality products with ever-shorter lead times. Most factories just don't have the tools and expertise to manage this effectively. So they put the squeeze on the workers. It's the only margin they have to play with."*[2]

Since 1994 the minimum wage for a garment worker in Bangladesh has remained at just 10€ per month (940 BDT). In reality, it has halved from that time on. In 2006, garment workers in Bangladesh went on strike to demand better pay and conditions. Unfortunately their calls were only heard to some extent. The national minimum wage board has now proposed raising the minimum to 17€ (1600 BDT), still just half of the most basic living wage.[3] In most cases and countries, the legal minimum wage has proved to be inadequate, if it is paid at all. Information from workers' organisations made obvious that the legal minimum wage was rarely based on realistic cost of living calculations. They were often established with little or no correlation to the wages that were essential to meet the fundamental needs of workers and their families. In some countries, legal minimum wages had consciously been set below subsistence levels to attract foreign investment. The suppliers are forced to compete against each other in order to fulfill the contract cheapest and fastest. Buyers play their suppliers against each other, sometimes even in real time using online reverse auctions.

Between 1997 and 2002 for example, average garment export prices in China fell by 30%, whereas production costs rose by 10% during the same period. A lot of pressure continues to be put on suppliers regarding the described practices. Now the question arises, how the retailers

---

[1] cp. LABOUR BEHIND THE LABEL, *Wearing thin – the state of pay in the fashion industry*, [online]
[2] cp. HEARSON, M., et. al., *Who pays for cheap clothes?*, (p 23) [online]
[3] cp. ALAM, K., et. al., *Fashion Victims – The real costs of cheap clothes of Primark, Asda, Tesco,* [online]

persuade them to agree to these terms. The answer is quite obvious; retailers hold the power in clothing industry supply chains. Some realize their terms and conditions by frequently swapping between suppliers, promoting competition and moving on as soon as they find a supplier willing to go cheaper and faster. [1] These practices are true for a lot of companies, regardless of whether it is a brand product or not. Often one and the same worker sews labels onto Nike, Reebok, Adidas, Puma and at the same time, an unknown brand of the particular sport shoes in series. Quality and working conditions of the several brands do not vary much, but the power rests with the big labels. Global market leaders – respectively the big brands – dictate the prices, terms and conditions of production plants and are therefore responsible.

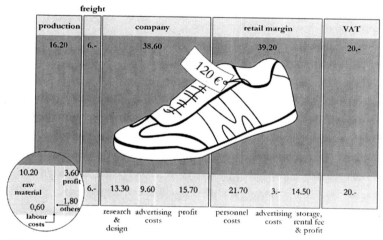

**Fig. 22: Where Does my Money Go?**

The chart shows the distribution of the consumer price of 120 € for one fashionable pair of sports shoes. About 0.5% to 1% of the consumer price goes to the workforce producing this shoe, whereas enormous budgets are used by companies for advertising strategies. Humane wages in Bangladesh of course differ from humane wages in Germany. It would be counterproductive or might even lead to social tension to adapt wages to European standards. An adequate living standard has to be assured under the given local circumstances. If 150,000 textile workers in Indonesia would earn about 11€ more per week, they could not only live a decent life but they would be able to send their children to school. The retail price would just increase by 0.36 €, which could easily be compensated through less advertising. As this is not the case, children are forced to work and support their families with their income.[2]

---

[1] cp. HEARSON, M., et. al., *Who pays for cheap clothes?*, (p 17) [online]
[2] cp. WEISS, H., et. al., *Das neue Schwarzbuch Markenfirmen*, (p 210)

### 2.3.4 "We made you, we break you!"

The reasons companies just do not pay more are related to the market mechanisms. To pay more than necessary contradicts the logic of free enterprise systems, even if we are talking 0,36 €. In 1997 Nike was made aware with the fact that consumers are no longer satisfied with glossy brochures. The social worker Mike Gitelson, who was in charge of adolescents in the Bronx, was tired of seeing the kids running around in shoes neither them nor their parents could afford. He told them about Indonesian worker earning just $ 2 a day and that it would cost Nike just about $ 5 to produce this kind of shoe. He went on that Nike does not produce any of these shoes in America but sells them there from $ 100 up to $ 180, and that outsourcing of

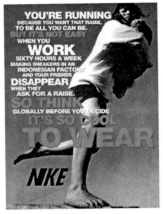

Fig. 23: Adbusters

factories was one cause their parents could hardly find jobs. The kids felt betrayed and sent letters to Nike's CEO Phil Knight to claim their money. But the company just responded with meaningless standard phrases, which made the youngsters really angry. They organised a demonstration. About two hundred eleven to thirteen-year-olds gathered in front of "Nike town", one of the company's adventure stores in New York. The kids brought garbage bags full of old sneakers and placed them right at the feet of a line of security guards. The New York Times, an ABC news team and local TV crews covered the event, surrounded by curious onlookers. One kid, a thirteen-year old boy from the Bronx, brought the message to the point - staring into the lens of the Fox News camera, he delivered a message to Phil Knight: *"Nike, we made you. We can break you."* Up to that point, Nike had defeated criticism by attacking opponents

Fig. 24: Protest at Nikestown, N.Y.

as fringe groups but this was different. Actions had to be taken, when the most wooed consumers scratch the costly veneer of the company. With this demonstration, the kids had accomplished what human rights organisations were fighting for over several years: Nike went on the offensive and confessed to abuses[1]

---

[1] cp. KLEIN, N., *No logo*, (p 372)

## 2.3.5   Clean Clothes Campaign

Different from the drastic measures of the above-mentioned operation, civil action in Europe is supported by the Clean Clothes Campaign. It seeks to improve working conditions and to empower workers rather than to boycott certain brands or products. Because well-targeted boycotts like "the stop Esso campaign" make sense, but crude boycotts often lead to a change to the worse for the persons concerned. It is quite easy for a company to close down a factory that has been in the public focus and take the same business elsewhere. They just have to rent a hall and set up sewing machines, i.e. that they can move on as fast as they settled, leaving hundreds of people unemployed.

In 1990 the Clean Clothes Campaign (or the "CCC" as it is popularly called) started in the Netherlands. The idea was born because stores were not taking any accountability for the circumstances under which their clothes were made. Today, there are campaigns in nine western European countries, making it hard to find retailers who denounce this responsibility. Campaigners have been collaborating with organisations in a variety of countries, including those where garments are produced. The campaign has established a network to draw attention to labour rights issues in the garment industry and to bring about long-term changes. Therefore, the Clean Clothes Campaign has four broad categories of activity that ultimately aim to move closer to the main goals.[1]

*Putting pressure on companies to take responsibility*
CCC demands retailers and brands to accept codes of labour practices based on International Labour Organisation standards. (ILO) Furthermore the campaigners have developed a model code as a directive and companies are pressured to have a code that requires full implementation of the standards listed. The crucial point in self-obligation is namely, that inspections are carried out by company-owned institutions.[2] Big brands refer consumers to their codes of conduct, when receiving protest letters. The codes definitely sound and look good, but they often lack three key commitments: guaranteed payment of living wages, guaranteed freedom of assembly & labour unions and monitoring and frequent inspections by independent institutions. Through its urgent appeals system, the Clean Clothes Campaign also put pressure on companies to take action on individual instances of labour rights violations.

---

[1] cp. BALZER, M., *Gerechte Kleidung- Fashion Öko Fair;* (p 312)
[2] cp. CLEAN CLOTHES CAMPAIGN, [online]

*Support of workers, trade unions and non-governmental organisations*

The CCC takes actions based on urgent appeals, and they also organise research and development programmes and international seminars. Their work helps build conditions where social standards and conditions can be discussed and developed. An important tool for these actions is the Internet.[1] On the one hand, it has accelerated globalisation with all its pros and cons; on the other hand, it embodies the most powerful instrument of severe criticism against big companies. Meetings are organised via Internet, strategies are discussed in forums and unethical companies pilloried on homepages. Non-governmental organisations take the operational and knowledge related lead, due to their international networking.

*Mobilising consumers*

The market is dominated by keen competition for consumer loyalty. Per annum, millions of dollars are spend on marketing campaigns to influence consumers' purchasing decisions. This power can be harnessed to bring about positive social changes, if the consumer is aware of this power. The Clean Clothes Campaign gathers information and presents it in educational programmes, demonstrations, ads, debates, books, rallies and the Internet. In that way, consumers can find out more about how their clothes are produced and are encouraged to accept their responsibility.

*Legal ways and lobbying*

Many countries that produce garments have good legislation, but execution is not taken very seriously. Although the CCC considers the governmental body as important for ensuring good labour standards, they have to take action to avoid creating an environment that is attractive to foreign investment at the expenses of their own people. Campaigners are fighting for governments to become ethical consumers and to stand up for the rights of their nationals.[2]

### 2.3.6 Code of Labour Practices

The Code of labour practices is a formal obligation that has been presented to all global textile companies by the Clean Clothes Campaign. It meets the minimum standards of the International Labour Organisation (ILO). Companies commit themselves to implement these standards. Moreover, they require their contractors, subcontractors, suppliers and licensees to observe these standards.

---

[1] cp. CLEAN CLOTHES CAMPAIGN, [online]
[2] cp. KAMPAGNE FÜR SAUBERE KLEIDUNG, [online]

- *Freedom of association*

  Workers have the right to freely associate. They are free to join independent associations or other lobbies, without the need for authorisation. During collective negotiations workers can be represented by organisations of their own choice. Organisational activities and trade unions shall be accepted by the employers.

- *Payment of living wages*

  The wages have to at least cover the demand of basic needs (food, clothing and living space) for workers and their dependent relatives, and meet legal minimum standards.

- *Working time*

  Weekly working hours and regimentation for payment of long hours must correspond to ILO standards. That means eight hours per day or 48 hours per week

- *Decent working conditions*

  Good health and safety conditions have to be guaranteed. Unusual punishments, physical violence, sexual and other harassment, and intimidation by the employer is strictly forbidden.

- *Ban on child labour*

  No workers under the age of 15 or under the compulsory school-leaving age shall be employed. (ILO Convention 138) All replaced child workers have to be given appropriate educational opportunities.

- *Protection against discrimination*

  Equity regarding performance and pay has to be supported by the employer. Discrimination by reason of race, skin-colour, sex, political opinion, religious belief or other distinguishing characteristics is strictly prohibited.

- *Compulsory labour*

  Forced, as well as bonded or prison labour is forbidden according to ILO conventions 29 and 105

- *Secure employment*

  Social security laws and working regulations are not to be avoided through use of labour-only contracting arrangements, to provide regular employment. [1]

---

[1] cp. WEISS, H., et. al., *Das neue Schwarzbuch Markenfirmen*, (p 218)

The Clean Clothes Campaign is of course not the only organisation working on these issues. They work closely together with a whole variety of organisations and networks. Similar campaigns exist in the United States, (e.g. Sweatshop Watch, United Students Against Sweatshops) Canada and Australia. International trade unions work on similar issues and several NGOs in European countries. After introducing ISO 9000 for Quality Management and the environmental management standard ISO 14001, there now exists Social Accountability 8000 (SA 8000). It was launched in 1997 as a voluntary standard for workplaces, also based on ILO und UN conventions. Like CCC and all other campaigns this is still voluntary but initiators are working hard to get it accepted as an international standard. [1]

Implementation of social standards clearly has to be seen as the first step of a self-determined development process. It is not the goal that has to be achieved, but basis for a constant improvement of working- and living conditions. Improvement and independent monitoring costs money, and for sure not just a few cents per piece of clothing. Companies nowadays pride themselves with codes of conduct, but they are not willing to pay more. Saving money in this way, means taking it directly from their workers pay checks.

## 2.3.7 The Discharged Factory

**Fig. 25: Textile Trade Issues in 2004 South Carolina Senate Race**

Today, most companies avoid production completely. One example for trade issues becoming of prime importance was the Senate race in conservative South Carolina in 2004: Free-trader Jim DeMint supported trade policies, which critics hold responsible for the loss of more than 50,000 jobs in the Republican state. As news broke that DeMint's campaign T-shirts were sewn in Honduras, his officials did not apologise. They defended his campaign saying, that the cotton in that T-shirt was from South Carolina. Adding they would rather like to have good-paid high-tech jobs, than going back to having textile mills in the South.[2] However, the state's strong support for George W. Bush helped DeMint defeat his opponent Tenenbaum by 9.6 percentage points.

---

[1] cp. SAI - SOCIAL ACCOUNTABILITY INTERNATIONAL, [online]
[2] cp. WASHINGTON POST; [online]

*"[In the age of the superbrand] there is no value in making things anymore. The value is added by careful research, by innovation and by marketing."* [1] says Nike's CEO Phil Knight. What this means for the workers in the Export Processing Zones (EPZ) was already discussed in the former chapters, but it also comes with threats for workers in western countries. It may be inappropriate in many ways to compare the relative privilege of workers in Europe with zone workers, but they also have to earn their living.

The new primary producers of our economy are the so-called brand builders. Brands are built in the mind, whereas products are built in factories. But it seems that brand-building comes at much higher costs than the products themselves, implicating the need to get rid of costly workers. Every workplace around the globe is influenced by the dark side of the shiny "brands, not products" strategy. Secure fulltime employment is replaced by temporary contracts and factory jobs are completely outsourced. Offering employment – the continuous kind, with benefits, holiday pay, a measure of security and maybe even union representation – has fallen out of economic fashion. The consequences are mass layoffs and closures of whole factories, which are represented as regrettable but necessary measures to boost performances. [2] Areas with a former strong regional textile industry are now facing high unemployment rates. Hundred of thousands of workers, most of them women, lost their qualified workplaces. Today, the German textile industry is located mainly in Bavaria, Baden-Wuerttemberg and northwestern Germany.

| year | Textile Industry | | | Apparel Industry | | |
|------|------------|-----------|---------|------------|-----------|---------|
| | enterprises | employees | +/ - % | enterprises | employees | +/ - % |
| 1980 | 1 620 | 303 879 | -2.2 | 2 435 | 248 779 | -3.1 |
| 1985 | 1 334 | 231 393 | -1.7 | 1 957 | 188 436 | -1.4 |
| 1990 | 1 197 | 209 443 | 1.9 | 1 720 | 164 029 | -2.2 |
| 1992 | 1 098 | 189 888 | -6.8 | 1 446 | 146 749 | -8.7 |
| 1995 | 1 296 | 150 744 | -7.9 | 1 076 | 105 872 | -12.8 |
| 2000 | 1 049 | 121 532 | -1.9 | 549 | 66 199 | -9.9 |
| 2001 | 1 018 | 118 672 | -2.4 | 487 | 60 832 | -8.1 |
| 2002 | 972 | 110 332 | -7.0 | 472 | 53 901 | -11.4 |
| 2003 | 916 | 101 775 | -8.8 | 429 | 49 142 | -10.7 |
| 2004 | 880 | 95 149 | -6.5 | 408 | 44 732 | -9.0 |
| 2005 | - | 88 335 | -7.2 | - | 42 183 | 5.7 |

Fig. 26: Enterprises and Employees in Germany

---

[1] KLEIN, N., *No logo*, (p 197)
[2] cp. KLEIN, N., *No logo*, (p 195 et. seq.)

Experts consider that jobs in work intensive mass-production will continue to be outsourced to low-wage countries. The chance for domestic production lies in high quality and fashionably sophisticated products, premium goods that demand a high degree of flexibility, innovations and quick response. [1]

## 2.4   Eco-labels

Nowadays more and more eco-labels are appearing on the market, especially in baby wear and next to skin clothes. They represent a very important instrument for customer information. Moreover, they also act as a marketing tool as companies can show that they are taking measures in environmental and social politics voluntarily. But information has not reached the consumer yet. Guidelines and restrictions are not transparent and lead to customer confusion instead of providing clarity. Product related signets for example, differ substantially in their aspiration level.

Eco-labels can either focus on the manufactured goods or the whole life-cycle of a product. Within this process a varying number of aspects can be taken into consideration. Until now the requirements of social aspects are often omitted. In general, one can differentiate between signets that originate from companies, public authorities (e.g. "Blauer Engel", "Euroblume") or non-governmental organisations like the Oeko-Tex standards. The significance of a label increases if different interest groups are involved in developing the signet. On the other hand, credibility decreases if criteria and processes are not transparent.

### 2.4.1   Who's Who in Eco-labelling?

The rising awareness of social and ecological aspects in the public has also led to an increasing amount of labels. IVN estimates around 70 eco-seals just on the German market. For sure, the voluntary commitment of companies is an improvement but it cannot substitute a uniform regulation. A study in the year 1997 showed that the oversupply of labels even resulted in the opposite effect: 62% of the consumers and 48% of the sales force perceived the credibility of eco-labels as very poor.[2] Nevertheless, some existing labels already provide good information and transparency. Some of the most important ones are listed below:

---

[1] cp. BALZER, M., *Gerechte Kleidung - Fashion Öko Fair: Ein Handbuch für Verbraucher* (p 12)
[2] cp. BALZER, M., *Gerechte Kleidung – Fashion Öko Fair; Ein Handbuch für Verbraucher* (p 425)

**IVN**                *facts:*

| | |
|---|---|
| Who? | International Association Natural Textile Industry |
| What? | Accredited social/ecological certification |
| Type: | Non-governmental organisation |
| IVN certified best: | Highest existing standard for natural textiles |
| IVN certified better: | Superior ecological quality |

**Fig. 27: IVN certified best**

The *Gütesiegel Naturtextil* is developed by the major players in natural textile industry. It is the first independent and common seal for product chain optimised eco-textiles. The differentiation between "IVN certified best" and "IVN certified better" offers the possibility to label garments that cannot be produced according to the best but still excel in their ecological criterion. The comprehensive approach of the signet is kept up by inspections of independent certification institutes at each production step. In laboratories tests of residuals are also done frequently.[1] In addition to the announced inspections, the institutes reserve themselves to spot check on monitored companies. Directives relate to handpicked cotton, a declaration of all substances used during the manufacturing process and the adherence of social standards according to International Labour organisation (ILO).[2]

**Euro flower**          *facts:*

| | |
|---|---|
| Who? | European eco-labels |
| What? | Reduced application of health and Environmental harming substances |
| Type: | Label of a public authority, allocation on a national basis |

**Fig. 28: Euroflower**

The flower label is not exclusively for textiles, but for more than 200 different manufactured goods. It is designed to support business to market products and services that are kinder to the environment. It includes public and private purchasers and makes it easy to identify them across the European Union, as well as Norway, Lichtenstein and Iceland. The European Eco-label is also part of a strategy aimed to encourage sustainable consumption and production. Guidelines

[1] cp. IVN, *Advantages IVN Naturtextil* [online]
[2] cp. BALZER, M., *Gerechte Kleidung – Fashion Öko Fair; Ein Handbuch für Verbraucher* (p 443 – 446)

for the flower seal have to be accepted by the majority of member states and adopted by the EU commission, before being valid for the next three years. The criteria create an agreement on a low but effective level. It raises the bar for mass production and allows entry towards a clean production. [1]

**Oeko-Tex Standard**     *facts:*

| | |
|---|---|
| Who? | International Oeko-Tex Association |
| What? | Worldwide accepted label |
| Type: | Non-governmental organisation |
| Standard 100: | Focus on human toxic aspects only |
| Standard 1000: | Complement of standard 100 |

**Fig. 29: Oeko-Tex Standard 100**

The Oeko-Tex Standard 100 is a worldwide uniform testing and certification system for textile and raw materials, intermediate and end products at all stages of production. Textiles are tested for harmful substances, which are prohibited or regulated by law, chemicals which are harmful to health, and parameters which are included as a precautionary measure to safeguard health. Based on its intended use, the tested textiles are allocated to one of the four Oeko-Tex product classes. The more intensively a textile comes into contact with the skin, the higher the human ecological requirements which must be met. In contrast to labels of the natural textile industry, it is laid out to test all kinds of materials. In means of health relevant requirements, the limit values of the Oeko-Tex 100 often exceed governmental regulations and limits. [2] Critics find fault with the term "Oeko" used on the label itself. They claim, it arouses associations and implies that it not only protects human health but also the environment. In fact, strict heavy metal limiting values for the end product pushes back usage of heavy metals in the production process, but still this is not included in the criteria catalogue. To promote environmentally friendly production techniques, the Oeko-Tex Standard 1000 and Oeko-Tex 100 plus was developed. Additionally, requests regarding production ecology and sustainability are considered, as well as introduction of basic elements of an environmental management system By the time all factories and businesses along the companies' textile chain are certified, the end-product is allowed to hold the title Oeko-Tex Standard 100 plus.[3]

---

[1] cp. UMWELTBUNDESAMT [online]
[2] cp. OEKO-TEX STANDARD 100[online]
[3] cp. OEKO-TEX STANDARD 1000 [online]

**Toxproof**                    *facts:*

Who?                TÜV Rheinland Group

What?               Concentration of toxic substances

Type:               Non governmental organisation

Fig. 30: Toxproof

The Toxproof label is issued by the TUV Rheinland, mainly to test the quantities of toxins in products. It is issued to a wide variety of finished products, like textiles, furniture, construction materials, paints, etc. A product carrying this signet indicates toxin levels well below official limits. [1]

**Fair Wear Foundation**          *facts:*

Who?                Fair Wear Foundation

What?               Focus on social standards

Type:               Non-governmental organisation

Fair Wear label:    FWF code of conduct

Fig. 31: Fair Wear Foundation

The Fair Wear Foundation was founded in 1999 in the Netherlands. It is an initiative of business associations in the garment sector, trade union, and NGOs. FWF is not dominated by business interests. Selections of prominent organisations are representing the board of the foundation. The board in turn is supported by a committee of experts, which assures a high level of independence. Currently, the Fair Wear Foundation is working hard to join similar initiatives in a European Initiative.

As said before, company owned labels often lack independent verification. Labour standards do not comply with international standards nor are inspections and improvement plans carried out according to an approved process. This is the reason why Fair Wear foundation has developed a code of conduct which its members can adopt. It covers three key points: Internationally accepted labour standards, independent verification and partners in production countries. Guidelines follow labour conditions and minimum standards of the International Labour Organisation, as well as local laws and regulations. [2]

---

[1] cp. LABEL-ONLINE, [online]
[2] cp. FAIRWEAR, [online]

**Comparison of listed Eco-labels**

|  | IVN better | IVN best | Euro flower |
|---|---|---|---|
| Perspective | life-cycle | life-cycle | life-cycle |
| Types of fibres | natural fibres, ecological cotton | ecological natural fibres | synthetic and natural fibres |
| Chlorine bleach | not accepted | not accepted | accepted |
| heavy metals in dyestuffs | exemptions allowed | no | limitting values of dyestuffs and sewage |
| allergenic and cancerogenic dyestuffs | forbidden | forbidden | forbidden with exmptions |
| Form- aldehyd in ppm | 20 | 20 | baby: 30 n.t.s.: 75 n.s.c.: 300 |
| Form stabiliser | just mechanical stabilisers accepted | just mechanical stabilisers accepted | chemical stabilisers accepted |
| social aspects | yes | yes | no |
| development and awardance internal / external | IVN, Institut für Marktökologie (IMO) eco Umweltinstitut, (external) | IVN, Institut für Marktökologie (IMO) eco Umweltinstitut, (external) | EU / RAL, Deutsches Institut für Gütesicherung und Kennzeich- nung e.V. (external) |

Fig. 32: cp. Gerechte Kleidung –
Fashion Öko Fair, Ein Handbuch für Verbraucher ( p 451)

## Comparison of listed Eco-labels

| | Oeko-Tex Standard 100 | Toxproof | Fair Wear Foundation |
|---|---|---|---|
| Perspective | end-product | end-product | - |
| Types of fibres | synthetic and natural fibres | synthetic and natural fibres | - |
| Chlorine bleach | accepted | accepted | - |
| heavy metals in dyestuffs | limitting values for heavy metals in the end product | limitting values for heavy metals in the end product | - |
| allergenic and cancerogenic dyestuffs | forbidden | forbidden | - |
| Form-aldehyd in ppm | baby: 30 n.t.s.: 75 n.s.c.: 300 | baby: 30 n.t.s.: 75 n.s.c.: 300 | - |
| Form stabiliser | chemical stabilisers accepted | chemical stabilisers accepted | - |
| social aspects | no | no | yes |
| development and awardance internal / external | International Association Oeko-Tex, Forschungsinstitut Hohenstein (external) | TÜV Rheinland (external) | Fair Wear Foundation |

**Fig. 32: cp. Gerechte Kleidung –**
**Fashion Öko Fair, Ein Handbuch für Verbraucher ( p 451)**

**The perfect label**

It is obvious that an authentic and simple classification system is needed. The consumer is unable to cope with the flood of labels existing, information has to be edited and presented to the end user in compressed form. The ideal eco-label should at least fulfil the following criteria, or better, exceed them if possible:

- *Independence:*
  Interest groups, consumer representatives, trade unions and environmental & conversation organisations are involved in the development of the label criteria and the award procedure. The influence of companies on these topics is controlled and limited.
- *Authenticity:*
  The award procedure should derive out of the ecological and social profile of the product or service offered. Measures are differentiated and can be controlled within an appropriate amount of effort. Allocation is done by a third party and is limited in time.
- *Transparency*
  Carrying out of an active information policy, complete documentation of processes involved, possibilities for consumers and organisations to complain, empirical testing methods
- *Product life-cycle:*
  Examination of the whole product life-cycle; from raw material/fibres to disposal
- *Sustainability:*
  Aspects such as conservation of natural resources, health protection and social justice are taken into consideration
- *Aspiration level*
  The aspiration level lies clearly above the standard of the market and brings out a dynamic adaptation[1]

The IVN-label comes very close to the above stated conditions, but as the audit for "better/best" signets is quite costly, many producers shy away from labelling their new collections twice a year.

---

[1] cp. BALZER, M., *Gerechte Kleidung – Fashion Öko Fair; Ein Handbuch für Verbraucher* (p 435 – 437)

## 2.5    Future prospective

The cure-all for the textile industry now seems to be European wide, or even global, regulations and binding guidelines covering all the problems discussed. But the question is, whether legislature actually has the power to face this economical global development. Reviewing the last chapter, until today this seems not to be the case.

Governmental action has therefore to be empowered by the consumer. They turn ordinary clothing companies into strong brands and can also do the opposite. Anna Lappé, bestselling author and public speaker on food politics, sustainable agriculture, globalisation and social change puts it in the following way .

*"Every time, you spend money, you're casting a vote for the kind of world you want."* [1]

Elected political representatives borrow their power from the citizens; likewise great brands just borrow their power from the consumers. Every company just makes improvements within the given limits of avoiding profit losses. Consequently, civil strategies should focus on generating high costs through loss of image. That means, to create awareness amongst consumers, so it becomes cheaper for companies to invest in higher loans and environmental measures rather than repairing images. Success highly depends on a good public image; every action taken to put this image in danger can be expressed in money. According to the principle; trust is good but control even better, consumers should no longer be satisfied with ads in glossy magazines showing happy foreign workers or with donations once or twice a year. Public awareness and accountability that underlines and helps implement legal framework could build the lane towards a sustainable future.[2]

---

[1] LAPPÉ, A., *Small Planet Institute,* [online]
[2] cp. WEISS, H., et. al., *Das neue Schwarzbuch Markenfirmen,* (p 37)

# A
# SUSTAINABLE
# LIFE-
# CYCLE

- SHOWN BY MEANS OF THE BLUE JEANS-

## 3    A Sustainable Lifecycle -Shown by a Pair of Blue Jeans

A pair of blue jeans can be found in almost every wardrobe in the western world. Europe and especially Germany are amongst the biggest fans of denim-wear right behind the U.S. The latest study of Global Lifestyle Monitor from COTTON USA proves that we own an average of 22 pieces of clothing made of denim. [1]

| | 15-24 | 25-34 | 35-44 | 45-54 | |
|---|---|---|---|---|---|
| Asia | 2.65 | 2.67 | 2.66 | 2.28 | |
| South America | 4.43 | 3.75 | 3.82 | 2.85 | |
| Europe | 4.44 | 4.01 | 3.99 | 3.46 | |
| U.S. * | 4.64 | 4.03 | 4.26 | 3.75 | |

**Fig. 33: How many Days a Week Do You Wear Denim Jeans or Shorts?**

As the chart above proves, denim has become an item of everyday life. Its chameleon-like ability to adapt to all kinds of different settings and the easy-to-suit, practical and comfortable image it holds has made it one of the most fashionable items in the industry. And, of course, blue jeans have also stepped into the focus of ethical clothing manufacturers. This chapter is going to show how an ethical pair of jeans could be manufactured "from cradle to grave" with regards to social and ecological components.

### 3.1    Blue Jeans Go Green

The lifecycle of a pair of jeans includes the following stages:

- Raw material
- Spinning
- Yarn dying
- Weaving
- Washing/finishing
- End use/disposal

---

[1] cp. COTTON INCORPORATED, *fast facts cotton*, [online]

This can be roughly divided into two major phases:

- The manufacturing stage; from raw material production to the possible treatments
- The end use (washing, ironing, etc) and their end life

Both of these above-mentioned phases can be held responsible for about half of the environmental impacts caused by a pair of jeans during their whole life cycle. In concrete terms this means that half of the impact is generated during the jeans manufacturing and the other half is due to the utilisation and the end of life. Consequently, the consumer plays the key role in this scenario. He can influence the first stage through his purchasing behaviour by buying eco-friendly pants. The second phase can be influenced and impacts minimized by adopting a sustainable user's behaviour.[1]

### 3.1.1 Raw Material

Most jeans are made out of 100% cotton. Basic requirement for organic denim is therefore the use of organic cotton. With a market share of 40%, Turkey is the main producer of organic cotton. About 80% of global organic cotton cultivation is covered by Turkey, India, USA and China. Furthermore zippers, buttons and rivets are used on a pair of jeans. To ensure a sustainable production all components should be natural and produced in an environmentally friendly way.[2]

*Cotton*

Conventional cotton is grown in monocultures. This leads to a great sensitivity for diseases and pests. The seeds are often genetically engineered or treated with chemicals. High amounts of fertilisers are used and the soil is depleted. Toxic risks for humans and aquatic life arise as a consequence of pesticides that reach the groundwater through excessive rinsing. The bases for organic cotton cultivation are organic agricultural systems that produce food and fibres. "The white gold" is grown in mixed cultivation and crop rotation to maintain soil fertility and to prevent threats that derive from monocultures. Toxic and persistent chemical pesticides or fertilizers and genetically modified organisms are prohibited. To give back nutrients to the farmland, organic dung like muck and mulch are used. Pests are defeated with non-hazardous agents such as natural attractants. Harvesting is done in the traditional way by handpicking the cotton. The conversion of conventional cotton cultivation towards organic cotton takes about three years. The farmer has to prove that he has tilled the land for 36 months without using chemicals. [3]

---

[1] cp. ADEME, *An environmental product declaration of jeans*, (p 7) [online]
[2] cp. RAGALLER, S., *New Ecology*
[3] cp. HESS-NATUR, *Textillexikon*, [online]

*Accessories- if it doesn't need to be there, take if off*

The traditional and newly added components of a pair of blue jeans include zippers, rivets, buttons and maybe even sequins. As these accessories mostly cannot be produced in an environmental friendly way, organic denim producers focus on clean chic. This is also supported by the current trend for stylish dark jeans i.e. each detail on the jeans is really there for a reason. Belt loops and labels are fastened and pocket corners and openings are secured through bartacks and other strong kinds of seams and stitching. In this way rivets are substituted and if desired a stylish detail can be added by using contrast coloured yarn. Zippers can be completely replaced by buttons. Here, the designer can choose from a variety of natural materials to make use of galvanised metal buttons obsolete. Buttons made of coco, wood or nacre are a fashionable alternative.

Regardless of the kind of cotton production some parameters are fixed, whereas others can be changed for the better. Primary energy and water consumption for example, do not vary a lot. The cotton still has to be exported from the crop growing countries and the water demand of organic cotton is still as high as for conventional plants. On the other hand, impacts are reduced by handpicking and the prohibition of fertilisers, pesticides and defoliants. The selection of organic cotton over conventionally grown cotton for denim manufacturing therefore upgrades the ecological balance of the product in the following terms: Usage/Consumption of resources, ozone layer depletion and production of solid waste is the same as for conventional cotton production. Emissions to air and emissions to water are decreased in the impact by 5% to 29%, aquatic eco toxicity even decreases by over 60%. [1]

## 3.1.2 Spinning

The problem during the processing of organic cotton is to keep it segregated from conventional cotton. The segregation at the farm level or at the selling point can more easily be assured than during the spinning operations. If conventional spinning and the spinning of organic cotton is done on the same machines, non-organic cotton has to be removed. All stages of production have to be accurately cleaned from conventional grown cotton and machines have to be prepared for the processing of organic cotton. It has to be assured, for every end product throughout the whole life-cycle that the stages of the production are transparent and can be measured at any given time.

---

[1] cp. ADEME, *An environmental product declaration of jeans*, (p 5)[online]

### 3.1.3 Yarn Dying

Denim, unlike some other cloths, is usually dyed before being woven. Indigo is used to colour large balls of yarn. To ensure that all layers are equally dyed, the yarns are dipped several times into the indigo mixture. It is known that small amounts of sulphur are used to stabilise the top or bottom layers of indigo dye. In former times indigo was extracted from several species of plants, but nearly all indigo used today is synthetic. It is almost exclusively used for dyeing warp yarn in the production of blue denim, because it is reliable, uniform and economic for mass production. [1]

**Fig. 34: Laundries from Jeans Factories Pollute Rivers and Groundwater in the City of Tehuacán, Mexico**

Indigo is not soluble in water. It must be reduced in alkaline conditions (vatting) and then converted back to the original insoluble form by oxidation in order to remain fixed onto the fibre. One can literally see that happening in front of one's eyes. When the cloth comes out of the dye vat, it is yellow, as it meets the air it oxidises and turns blue. The final step in indigo dying is the after-treatment of the material. The denim fabric is washed in weakly alkaline liquor at boiling point with a detergent. Excess pigment particles are removed and amorphous dye particles are allowed to crystalline, the material gains its final shade and the fastness properties of typical vat dyes. Exhaustion levels of vat dyes are high and vary between 70% -95%. Due to their production process, vat dyes contain heavy metal impurities. Furthermore dispersants are present in the dye formulation. Since they are water-soluble and poorly degradable, they are found in wastewater. After the dying process the dyed yarn is slashed to make the threads smoother, stronger and more resistant to abrasion. The size is a film-forming polymer such as starch or polyvinylalcohol. Once the sizing is complete, the warp threads are ready to be woven with undyed filling yarns. [2]

Natural Indigo is one of the oldest dyes used for textile dyeing and printing. The word originally means a dye from India. Many Asian countries, especially India, have used Indigo as a dye for centuries. The production of natural Indigo drastically decreased, as synthetic indigo was invented by a German chemist in 1878. The colorant in synthetic and natural Indigo is the same but industrial Indigo is much cheaper. For 100% organic denim, this means avoiding

---

[1] cp. WIKEPEDIA, *Indigo dye* [online]
[2] cp. LACASSE, K., *Textile Chemicals – Environmental Data and Facts* ( p. 305)

environmental hazards during this stage of production, by using real Indigo plant dye. Indigo can be obtained from a variety of plants, such as Indigofera, Storobilanthes and Polygonum.

Most popular for denim dyeing is Polygonum tinctorium, an annual crop cultivated for example in South East Asia. Planting season is in spring and in summer Polygonum grows to be cut. The leaves are separated from the stems, they are collected and then have to undergo a fermentation process. Similar to the synthetic dye, natural plant Indigo is not water-soluble and cannot be used directly for dyeing. Industrial methods use reducing reagents such as hydrosulfite, whereas a traditional method for the reduction of indigo is the fermentation. This procedure has to be accomplished under moist and warm conditions. Indigo, bran or flour and ash of wood are placed in huge vessels located underground. The proceeding of the fermentation process has to be checked frequently. Blue bubbles on the surface of the vat indicate the end of the process and therefore the successful reduction of Indigo. At this point the dyers can carry on with the dyeing process. Most yarns used for denim production are rope dyed. As the concentration of reduced Indigo is quite low, the warp threads have to be soaked in the dyebath a couple of times. The process is repeated until the ropes have a deep blue colour. [1]

The fact that no uniformity in dyeing can be achieved by natural dyes is the major argument against natural plant Indigo. Some companies therefore compromise and use 50% of synthetic Indigo. They fear that customers will not buy from labels where all jeans have different shades and colours. Others, like the British label Howies, make capital out of the special dye property Customers are being convinced of the individuality of their pair of denim. Yarns from different dye batches are mixed during the weaving process to create different colour variations. Streaks of colours range from deep indigo purple to indigo blue and add an extra twist to the hunt for the perfect jeans. They state on their website:

*"Over the years, and through wear and washing, these jeans will change colour and develop their own character, as the beauty of the uneven ring spun yarns is brought to life, and the natural plant Indigo slowly fades."* [2]

The extraction of Indigo is a time-consuming course of action which desires highly skilled people. Technical problems, availability and a lack of knowledge are barriers to be overcome. Even if one would like to abandon synthetic Indigo from today on, there would not be enough supply to cover demand. But interest in natural dyestuffs that were revived from increasing cases

---

[1] cp. GILDEDAGE, *Natural Indigo Jeans* [online]
[2] cp. HOWIES, *Plantation Denim* [online]

of allergic reaction against synthetic dyes and changing environmental considerations, has stimulated development. [1]

Not considering what dye type is used during production, there are plenty of opportunities to reduce the impacts of dyeing elsewhere in the process. Dyestuffs and water can be used more economically by better planning, putting more material in one dye bath and avoiding making up full dye baths for a small amount of yarn. Chemicals can be reused by adding darker dyestuffs to dye baths previously used for lighter colours or rinsing water from lighter colours can also be used as influent to wash materials with a darker colour. It is also worth rethinking the dyeing method that is used. The most reliable and environmentally safe dyeing procedure is the cold pad-batch dyeing, also known as the semi-continuous dyeing process. It is suitable for cotton, rayon and blends. The fabric is dyed, the excess is squeezed out and the fabric is stored. To allow dye diffusion and fixation to take place, it is stored for 4 – 12 hours.[2] Applying this method can result in waste reduction, simplicity and speed. In some situations, water consumption can be reduced by 90% and energy consumption by 75%. Furthermore, utilisation of dyestuffs, chemicals and floor space are also reduced.[3]

### 3.1.4    Weaving

Most denim today is woven on a projectile loom, i.e. the differences in ecological production of a pair of jeans focuses on the sizing and desizing agents. Energy consumption is the same for ecological and conventional production. As mentioned above, sizing is used to protect the warp from the stresses of weaving. Chemical substances like polyvinyl alcohol are mostly used in conventional industries. But there are also natural alternatives for sizing that denim producers can use in order to strengthen and smoothen their yarns. The most common natural size is starch. It can be derived from various substances, especially corn and potatoes. Starch can be removed completely biologically, but it is only sparingly soluble in water. For desizing the action of vegetable enzymes or animal enzymes is needed. They decompose the starch into water-soluble sugars, and everything is removed by washing before scouring. Because starch cannot be recycled, it is responsible for most of the COD load in finishing effluents. Consequently starch is in fact biological but also not the perfect solution to substitute chemical agents. An alternative for starch is Chitosan as the basis for a natural sizing agent. It is a natural polymer and can be extracted from shells of marine animals. Every year nature produces about 1,010 tons of the basic

---

[1] cp. RAGALLER, S., *New Ecology,* (p 60)
[2] cp. INGARNELLS, W., *Colour for textiles – a user's handbook*, p (41)
[3] cp. TROTTER , C., *Dyeing for a change* [online]

form Chitin. For this reason it can be considered as a renewable primary product with a big a long lasting potential. Waste products are provided from fishery for usage in the industrial and commercial sector.

**Fig. 35: Visual Comparison of Sizing Effects**

Food, agriculture, cosmetics and medical science can already be found amongst the application field of Chitosan. Sizing agents on the basis of Chitosan opens up new ecological pathways in weaving and advancements in fibre and fabric properties:

- Biologically degradeable
- High adhesion power
- Alternative for synthetic agents
- High recovery rate by ultrafiltration and precipitation

In addition to the above-mentioned advantages, the effluent load of wastewater from the finishing department is minimised. Furthermore the aspect of recycling has positive effects in terms of the ecological and economical balance. Another important aspect of Chitosan in this context is the fact that it can be left on the fibre. Properties of innovative and functional fabrics as well as technical textiles can be changed and enhanced by the characteristics of Chitosan. The sizing agent can be kept on the fabric for anti bacteria functions, wound healing or antistatic behaviour. Furthermore the water polluting process of desizing and the according energy input to heat the water and to dry the textiles do not apply for such products.[1]

### 3.1.5 Washing/ Finishing

Each season new styles and options are offered to us by jeans companies; Jeans with faded yellow patches on the thighs, black hip-huggers with low pockets on our derrière, three dimensional cuttings or natural appearing abrasions. Chemists and denim experts are trying hard to find out new ways and substances to create their styles. There are companies, like the Italian based

---

[1] cp. STEGMAIER, T., et.al., *Entwicklung von Schlichtemitteln auf der Basis von Chitosan* (p 651)

company Garmon, which are only specialised in the production of chemicals for the textile finishing industry. The last boom of these chemicals was about two years ago, when torn jeans were all the rage. As big as the variety of jeans offered on the market, as plenty are the finishing and washing techniques that are used in conventional denim production. Listed below are some of the most popular:

*Abrasion*

To make a pair of jeans look worn or faded, laundries use abrasion. Pumice stones, sandpaper, grinders, and so on provide mechanical abrasion. Whereas for chemical abrasion enzymes, bleach permanganate and reducers are used.

*Acid wash*

The famous acid wash-look was first introduced at the Inter-Jeans Fair in 1986. The look created a hype, which was followed by a flood of varieties. For the procedure, pumice stones are soaked in chlorine bleach and then dry tumbled and washed. Very irregular contrast splotches are created on the entire surface of the garment. Until now, the acid wash remained a trend of the 80's

Fig. 36: Acid Wash Trend

*Bleach*

Bleach is usually an aqueous solution of sodium hypochlorite. It is mostly used to make denim jeans fade. For a long time sodium hypochlorite was the most used bleaching agent in the textile finishing industry. It is responsible for the presence of hazardous AOX's such as trichloromethane and chloroacetic acid in the effluent. Although it has been largely replaced in Germany and other European countries, it is still in use in many part of the world.[1]

*Stonewash*

It is the most common practice to wash denim. In order to get abrasion on denim, pumice stones, enzymes and sometimes bleach are added in the wash. The water temperature, stone size and length of washing time all affect the final appearance of the jeans. An average course of stonewashing for 130 pair of jeans lasts one hour and uses up 682 litres of water.

---

[1] cp. LACASSE, K., *Textile Chemicals – Environmental Data and Facts* ( p. 100)

*Whiskers*

Whiskers are the lines on the lap and legs of jeans from continued wear. In the laundry, these whiskers are created by hand using sanding tools or Potassium permanganate. PP or $KMnO_4$ is a dark purple crystalline compound, used as an oxidizing agent. It can create very dramatic hi-contrast blast patterns. The areas of denim treated with PP turn white and create the whiskers pattern.[1]

Fig. 37: Whiskers Wash

Companies still invest money in developing chemical substances instead of investing in ecological alternatives. Opportunely, the prevailing trend for dark, clean and nearly unwashed denim accommodates the green movement.[2] As fashion changes, companies are given the chance to work on more environmentally safe methods before these styles come back into fashion. Levi's for example discovered ordinary stones and Marseille soap for their washing processes. For the finishing processes potato starch and Mimosa flower are used. But also other denim labels have become quite inventive when it comes to alternative finishing processes. After experimenting with golf balls, the British label Howies discovered so called "Eco-balls" to wash their jeans. Because even if a pair of jeans is called unwashed, a certain amount of washing has to be done to make sure that the Indigo dye does not come off on people's hands and shoes. Unfortunately, the denim finishing process as a whole is far away from being environmental friendly. Moreover, the development of ecological alternatives is still in its infancy, but research is being done to meet customer's expectations and environmental demands.

### 3.1.6    End use/ Disposal

The word fashion implies that pieces of clothing are not designed to last very long. This is not meant in terms of being worn out, but being not fashionable anymore. Physical wear and tear is usually the least important reason to buy new clothes. Still usable garments are thrown away, while new ones are being produced. Yet with no changes in fashion, seasonal trends and our affluent society are the driving forces behind excessive clothing consumption. Consumers do not wear garments enough, wash them too often, and at too high temperatures. The study "Well dressed" carried out at the University of Cambridge found out that the use phase of a cotton garment, in this case a plain T-shirt, requires just as much energy as needed for the production phase. In comparison to cotton, textiles made of synthetic fibres have a high energy consumption during their production stage. However, over their lifetime these textiles require less than half of

---

[1] cp. SCHINDLER, P. U., *The Jeans Encyclopaedia*
[2] cp. RAGALLER, S., *New Ecology*

the energy that is necessary to manufacture and maintain cotton garments. The main reason for this discrepancy is the fact that man-made fibres can often be washed at lower temperatures, can be hung dry and do not need to be ironed.[1]

*Consumer liability*

So, what does this mean for the example of the blue jeans? Do we now have to fill our wardrobe with polyester pants to clear the way for a sustainable future? Taking the other environmental impacts of man-made fibres into consideration, especially the use of raw oil, the answer would be a clear "no". Once again, consumer action and responsibility are in demand. Parameters with the greatest influence are the way of cleaning and the utilisation frequency. Again, this stage lies in the full responsibility of the consumer.[2]

*Responsible purchasing*

The easiest method to make an environmental friendly purchasing decision is to buy long lasting clothes and also wear them for a certain amount of time. Because keeping clothes longer reduces the production impacts. Even the best and most sustainable ways of production & transport fail if the garment is thrown away too early. In terms of a pair of jeans this means to focus on the quality of the material and manufacturing. Critical seam should be double or even triple stitched and secured by back stitchings. To avoid the tearing of pockets, they should be secured by industrial strength bar tacks. One should also avoid materials, especially threads that are treated with bleach. Bleach weakens cotton and might lead to an early wearout.[3]

*Utilisation phase*

As mentioned before, half of the environmental impacts caused by jeans, or clothing in general, are caused during the utilization stage. A piece of clothing has to be maintained, including washing, drying and ironing, but it is up to the owner how to do this. These choices have a great impact, regarding the ascendancy of the utilisation phase in determining the environmental impact. The influence of these factors is presented in the table next page. The calculated percentages may seem modest, but once they are multiplied with the number of existing pants, they become quite impressive.

---

[1] cp. ALLWOOD, M.J., et. al., *Well dressed?*, (p 29)
[2] cp. ADEME, *An environmental product declaration of jeans*, (p 6)[online]
[3] cp. HOWIES, *Are you happy with your wash?* [online]

| Reminder: reference scenario | Studied alternative | Resources | | Emissions to air | | Emissions to water | Toxic risks | | Prod. of solid waste |
|---|---|---|---|---|---|---|---|---|---|
| | | Primary energy consumption | Water consumption | Global warming | Ozone layer depletion | Water eutrophication | Human toxicity | Aquatic eco toxicity | |
| Jeans are washed after they have been worn 3 times | Jeans are washed after they have been worn 5 times | ⬤ | ⬤ | ⬤ | ⬤ | ⬤ | ⬤ | = | ⬤ |
| Class C washing machine used at 40°C | Dry cleaning | ⬤⬤⬤ | ◯ | ⬤⬤⬤ | ⬤⬤⬤ | ⬤⬤ | ⬤⬤⬤ | = | = |
| | Class A washing used at 0°C | ⬤ | = | ⬤ | = | = | ⬤ | = | = |
| | Class D washing used at 60°C | ◯ | = | ◯ | = | = | ◯ | = | = |
| Ironing | No ironing | ⬤ | = | ⬤ | = | = | ⬤ | = | = |
| No dryer | Dryer | ⬤⬤⬤ | = | ⬤⬤ | ◯ | ◯ | ⬤⬤⬤ | = | = |
| 50% are thrown away, 50% are reused | 100% is reused | ⬤ | ⬤ | ⬤ | ⬤ | ⬤ | ⬤ | ⬤ | ⬤ |
| | 100% is thrown away with muicipal waste | ◯ | ⬤⬤ | ⬤⬤ | ⬤⬤ | ◯ | ◯ | ⬤⬤ | ◯ |

=    variation in the impact < 5%

decrease in the impact between 5 an 29%
increase in the impact between 5 an 29%

decrease in the impact between 30 an 59%
increase in the impact between 30 an 59%

decrease in the impact > 60%
increase in the impact > 60%

**Fig. 38: Utilisation Stage**

| Reminder: reference scenario | Studied alternative | |
|---|---|---|
| Jeans are washed after they have been worn 3 times | Jeans are washed after they have been worn 5 times | To reduce the frequency of washins allows a decrease in washing powder consumption and the utilization of washing machnies and irons, which consumes much energy |
| Class C washing machine used at 40°C | Dry cleaning | When washing the same quantity of clothes, dry cleaning consumes more energy, more water (cooling circuit), and notably requires a solvent, named perchlorethylene, whose production and use generate polluting emissions in the air |
| | Class A washing used at 0°C | The more the washing machine belongs to a high energy class, and the higher the washing temperature, the more we consume electricity.The production of electricity generates greenhouse gases, which are responsible for global warming. It is also responsible for the emissions of substances which present a toxic risk for humans |
| | Class D washing used at 60°C | |
| Ironing | No ironing | Likewise, irons and dryers have an important electricity consumption: a dryer consumes about 5 times more energy than a washing machine! |
| No dryer | Dryer | |
| 50% are thrown away, 50% are reused | 100% is reused | To give or sell one's jeans to a second user is the equivalent of anextension of the jeans lifetime, and thus the number of days during which they will be used. To increase one's jeans lifetime corresponds to bring down the manufacturing impacts to a greater number of days during which they will be worn, therefore decreasing the impacts on a single day. |
| | 100% is thrown away with muicipal waste | |

**Fig. 38: Utilisation Stage - Evaluation**

*Reuse*

When it comes down to customer responsibility in the usage phase of a pair of jeans, the classical waste pyramid can be applied. The main goals should be to avoid and reduce textile waste by smart shopping decisions and extension of lifecycles, as described above. But also reuse and repairing can be part of sustainable customer behaviour. In less wealthy countries and in less wealthy times in Germany, repair is and used to be a normal activity. One or two outfits can last a

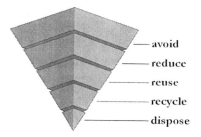

person for many years. Websites like "Junky Styling" (www.junkystyling.co.uk) and "Jeansmakers" (www.jeansmakers.com) discovered this sector as a market niche and offer services to turn one's old pair of jeans into a designer piece. Furthermore, second-hand clothing is a good alternative. In fact, it has become quite popular again, since "Ebay" and other auctioneers make it possible to sell

**Fig. 39: Author's View on Waste Pyramid**

worn clothes on the Internet. A pair of jeans from a known brand still achieves reasonable prices and the "used effect" is added for free and without further environmental hazards.

*Social standards*

As described in the second chapter, it is hard to keep track within the flood of labels. Once again, the consumer has to take action. Fair traded clothes are still not available everywhere. To be on the safe side, one can prefer regional or European Manufacturers to others. "Made in Indonesia, Thailand or China etc." often implies bad payments for workers, persecution of trade unions and exploitative child labour. The more information provided by the label about their product, the better. When it comes to transparency, the influences and power of consumers should not be underestimated. Entire crisis management groups come together if companies receive a variety of protest letters. If a consumer buys a pair of jeans "made in Indonesia", he could prevent standardised answers from the marketing department by asking specific questions like: In which company these jeans were produced? What is the minimum wage for workers who make these jeans? Which autonomous institution is checking on labour conditions? Could you refer me to a contact person or organisation that can confirm your data? If a company gives wrong answers, they have to at least fear being severely criticised by public media.[1]

---

[1] cp. WEISS, H., et.al. *Das neue Schwarzbuch Markenfirmen*, (p 54)

A good example of voluntary self-commitment is the Dutch label "MADE-BY". It is an "umbrella" label, which can be used by fashion brands to state that their products are produced in a sustainable manner. Now, the crucial factor for the customer is that the brand production data is linked to the labels own track & trace system. This allows consumers to get informed about the place where their garment was manufactured and the many stages it has passed through. Customers can find an individual code on the hangtag or carelabel, which can be used to trace the production line. The code can be typed in on the "MADE-BY" website and gives information about the production sites and makers.[1]

The textile and clothing industry has always suffered from transparency troubles. Companies have been unwilling or even unable to provide much information about their supply chains and production methods. But, a fact is that when you have nothing to hide it can be a good marketing tool for companies to literally wear their heart on their sleeves. Transparency can be a tool to create trustworthiness between the company and their customers and employees. It can produce a hugely positive profile or image and therefore add value directly to the company's brand. It is about doing the right thing and communicating these beliefs to everyone who is or likes to be involved with the company. Furthermore transparency can positively influence purchasing decisions. Customers are given more reasons to believe in and choose a brand when they are able to know more about the product and its whereabouts. Also consumers are likely to pay more for a product if a company gives specific and tangible reasons. This again gives a company the chance to build and protect their profit margins.[2]

*Disposal*

As described in the second chapter, the afterlife of clothes is a mixed blessing. Assuming that, up to this point in time, the perfect pair of organic jeans were produced ecologically, carefully chosen by the consumer, worn for a number of seasons, repaired several times and sold in a second hand shop to serve another customer for the same amount of time, then it would finally be time for disposal. Having only components, which can be fully biodegraded, the organic denim could then end its life accompanied by coffee filters and orange peels in the bio bin. A vision that is not as far away as it might seem. Trigema, the largest T-shirt and sports clothing manufacturer in Germany launched a completely biodegradable T-shirt in 2006.[3]

---

[1] cp. MADE-BY, *What do we do ?* [online]
[2] cp. BETTER THINKING LTD. *Why transparency?* [online]
[3] cp. MELLIAND, *Trigema: kompostierbares T-Shirt* (p 84)

Together with the EPEA Umweltforschung GmbH in Hamburg/Germany, they have developed a tee which can be broken down into substances which are all part of the known biological cycle. The T-shirt consists of 100% organic cotton that is imported from USA and Pakistan. The pesticide and fertilizer free cotton is then spun into yarn with natural paraffin by a third party. The knitting, dyeing and manufacturing of the product is done by Trigema itself. To achieve this, Trigema collaborated with the Swiss corporate group CIBA SC AG, Basel. They developed human- and eco-friendly dyestuffs, which are reported to be longer lasting and truer than standard dyes. Trigema claims to continue with pioneering investigations for biodegradable buttons zippers as well as development of new plastic raw materials from natural resources.[1]

*The ideal consumer*

Unfortunately, these ideas do not seem to be very appealing for most of the companies and customers yet. But the problem with a more sustainable future on the textile and clothing sector is that the benefits arising from changes in the behaviour of a few pioneers are not really big. Moreover, there are several barriers that keep consumers from preferring conventional blue jeans to organic denim. One argument is the price. In the long run, longer lasting clothes with environmental and social responsibility will not be able to compete against dumping prices. Furthermore, most consumers are not really aware of the connection between their purchase and the social and environmental consequences.[2]

Besides spending more money, there are actions that can be taken by everyone during the consumer phase of garments. In order to promote the best environmental and social performances of a pair of jeans the following measures are crucial:

- Purchase of products made with less energy and least toxic emissions
- Long lasting products with timeless style for life-cycle extension
- Gathering information about social standards of manufacturers and their practices
- Washing at lower temperatures to reduce environmental impact
- Leaving out of tumble drying
- Usage of eco-friendly detergents
- Repair of worn clothes[3]

---

[1] cp. MELLIAND, *Trigema: kompostierbares T-Shirt* (p 84)
[2] cp. RAGALLER, M., *New Ecology* (p 60)
[3] cp. ROSENTHAL, E., *The New York times – Can Polyester save the world?*, [online]

# IS GREEN THE NEW BLACK?

4

# 4    Is Green the New Black?

At the end of the last century the desire for tomorrow and a far-off future were the main influencing factors in our society. In a fast-changing world "the new economy" raised high expectations and actuality became very important. The cultural significance was even supported by the year 2000, to which utopian futures often referred to. Today, nearly nothing is left of this longing for the future. Dark prognoses have not come true and the excitement due to the millennium is also over. However more remarkable events happened in the meantime. The years since 2000 have been clouded by the 11.September, the war in Iraq, natural catastrophes like the Tsunami, the hundred year flood and global warming as well as the bird flu and the scandal about rotten meat. These anchor points have had a major influence on how people stand in this world today. We move together, international alliances are contracted and the European expansion was already agreed upon. It seems like time stood still and made us aware what really is at stake. The pictures that are nowadays drawn of the future are different. Finally, after decades of ignorance and neglect people are starting to realise that thinking about the future is not only valuable but indispensable.

So what does this mean for fashion, or to be more precise for ethical clothes? More and more people are doing the right things, not necessarily for the right reasons but this is a different story. Social and environmental responsibility evolves from the re-appreciation of old values and traditions. Customers today are becoming more conscious. They question the story behind a piece of clothing or even demand the availability of ethical clothing. In defiance of the "dirt-cheap" culture, values instead of prices are crucial. But what makes the difference? Why should this not just be another trend? The theory to be proved is that once the step ahead is taken, there is no turning back from being ethical or green.

## 4.1    Future Studies

Before looking at clothes in particular, one has to have a look at the world we're going to dress up for. This is not meant to sound apocalyptic, but even the biggest sceptics have to admit that something is going to change. Enormous challenges due to a growing world population, demands for higher standards of living, a need for a reduced amount of pollution, a need to avert global warming, and a possible end to fossil fuels have to be accepted. The world's entire industrialised infrastructure depends on energy. And this is not a new threat we are facing.[1]

---

[1] cp. WIKIPEDIA, *future energy development*, [online]

Ever since the start of the Industrial Revolution, economists were occupied with the question of the future energy supplies. This chapter is going to present selected views and findings of the economist Nikolai Kondratieff, the author and economist Dennis L. Meadows and the SIEMENS Horizons 2020 study about how our future will or has to look like.

### 4.1.1 Nikolai Kondratieff – Long Waves in Economic Life

In 1926 the Russian economist Nikolai Kondratieff published an article named "The long waves in economic life." He asserted in this paper that European and American development was not only dependent on short and medium-sized economic fluctuations, but that in capitalistic countries also long phases of prosperity and recession occur frequently. He allocated duration of these periods to 45-60 years and called them waves, due to the fact that the long-term cycles of boom are followed by depression. He was the first who brought international attention to this observation and therefore gave the impulse for a new direction in economic research. The great advantage that is provided by the long wave theory is its holistic approach towards the problems of a given time. Interactions between technical, economic, social and mental factors are explained convincingly and allow stable short-and long-term prognoses. Furthermore, this represents the possibility to refer to the structural change as a whole a major concern of economics and politics.

Kondratieff waves are economic fluctuations that are caused by pioneering improvements, called "basic innovations". Until today, there have been 5 waves which were accompanied by the according basic innovations:[1]

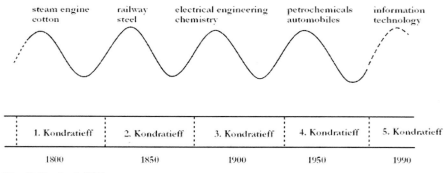

**Fig. 40: Kondratieff Waves**

---

[1] cp. NEFIODOW, L., A., *Der sechste Kondratieff* (p 3)

All waves can be divided into four parts; prosperity, recession, depression and improvement, they last about 45-60 years and are released by the next basic innovation and the corresponding wave. The Kondratieff waves can be considered as a value chain that determines the economic growth and includes, as well as changes, all regions of economics.

The theory of the Kondratieff waves was taken up by the economist Leo A. Nefiodow, who got to the bottom of the more or less pre-programmed sixth wave. The five waves with focus on clothing, mass transport, mass consume, individual mobility and information or rather communication have all been introduced by a basic innovation, e.g. the utilisation of the steam engine in textile and clothing industry or the invention of the automobile. Nefiodow says that in contrast to this, the currently rising sixth wave is founded on a general change in society rather than in concrete single technologies.

His forecast for the sixth Kondratieff wave is the focus on the health care market.[1] Not just in a physical way, as we understand it today, but in an integrated mode; including mental, ecological and social health. He substantiates his theory with the demographic trend of an increasing average age. According to Nefiodow, not just superficial factors such as food, fitness and leisure time will grow in importance but the awareness itself will gain a certain self-dynamic. He predicts that society will turn its back on ideologies where humans are just measured by performance and efficiency. As clear evidence Nefiodow quotes the recent wellness trend as a step into a new understanding of health and life quality.

### 4.1.2   Dennis L. Meadows – The Limits to Growth

"The Limits to Growth" is a study published in 1972 commissioned by the Club of Rome, dealing with the future of the world economy. Dennis L. Meadows and his colleagues simulated the consequences of interactions between the Earth's and human systems using the computer system World3. Different scenarios were developed taking five variables into consideration. These variables are: world population, industrialisation, pollution, food production and resource depletion. By altering growth trends among the five variables, the authors intended to explore the possibility of a sustainable future.

---

[1] cp. NEFIODOW, L., A., *Der sechste Kondratieff*

**Fig. 41: Dennis L. Meadows**

Meadows and his co-workers found that all the variables stated in the study are growing exponentially. Exponential growth is commonly defined as the increase by a constant percentage of the whole in a constant time period. This is mainly due to the correlation of the variables, i.e. population cannot increase without food, the production of food is enhanced by growth of assets, and more assets require more resources. The consumption of resources in turn leads to pollution and pollution interferes with both, the growth of population and the growth of food. It is a dynamic phenomenon, which means that it involves elements that change over time. Unfortunately certain factors like the non-renewable resources are not subject to growth.

The result of the study was that if tendencies of growth were not changed for the better, the existence for the main part of mankind would not possible until 2100. Opponents often criticise the insufficient evidence for many of the variables used in the model. Whereas results and conclusions of this study seem logic if just looked at with common sense. Population, food stuff, resources, pollution and capital are changing variables. These quantities do not grow unrestrictedly; they come to their limits, because also the world is finite.[1] In 2004 the 30-year update of the study was published. Data used for the first scenario analysis in 1972 was modernised and slight changes on the computer programme were carried out. As thirty years before, the study revealed that resources were taken far beyond their limits. It said that the capacity of mother earth's resources and the ability to absorb pollutants was already exceeded in 1980. It says further that this will result in overshoot and collapse by 2100 at the latest. Still worse, by continuation in business as usual the system collapse will be reached in 2030. According to Meadows, even vehement realisation of environmentalism and efficiency standards can just temper the tendencies but not prevent them from occurring.[2]

### 4.1.3   Siemens – Horizons 2020

Also Siemens, one of the world's largest engineering firms, has begun to search for answers about our future living. The study called Horizons 2020 gives, as well as Kondratieff and Meadows, answers to what life could possibly look like in the world of tomorrow. Experts have been asked about economic, technological and social developments within the next 15 years. Due to the

---

[1] cp. MEADOWS, D., L., et. al., *Wachstum bis zur Katastrophe*, (p12)
[2] cp. WIKIPEDIA, *Limits to Growth*, [online]

smaller period of time that is taken into consideration, the study is able to give more differentiated answers. Siemens decided on five important life areas that are expected to drive change in the next years; the political arena, society, the economy, the environment, and technology. These metrics were further subdivided into mega trends, critical descriptors and non-critical descriptors. The outcomes are two scenarios that will offer a large number of starting points for dialogue and debate rather than offering a precise roadmap of the future. Two alternative courses of development were defined. The chances that one of the drawn scenarios will come into being are balanced, but it could also be just somewhere in-between.

*Scenario 1: equality, freedom and modesty*

The key role in this first scenario is played by government and the political arena. Out of the renewed faith in government evolves the possible most outstanding change since 2005; the "faster, higher, further" mentality is substituted by the rediscovery of the joy of taking things slowly. Society is affected by solidarity towards others and the motivation to put the interest of the community first. An equal distribution exists between the desire to achieve and the sense of social responsibility. These values are not only favoured by individuals, but also by businesses. Companies place increasing attention on social responsibility and community initiatives. Corporate governance and corporate responsibility are no longer abused for image reasons but are the basis of good citizenship. The state, the corporate sector, and the individuals all become active in environmentalism and take measures to conserve resources. [1]

Consumer behaviour in the first scenario changes from brand-powered markets to a preference of no-name products for daily needs. The focus on the real value of products and purchase behaviour is driven by loyalty towards products rather than brands. This leads in consequence to a renaissance in small series production forms (such as furniture, foodstuffs and textiles) and built the counterpoint to mass-produced goods

*Scenario 2: speed, networks and risks*

In the second scenario, markets and global competition play a key role. People are willing to take greater responsibility but this also bears considerably higher risks for the individual. People recognise the power of self-responsibility, the chances to create the life they want and to achieve self-fulfilment. The downside of a society following the principles of open competition and an absence of government regulation is the resulting divide of society into two classes.

---

[1] cp. SIEMENS, *Horizons 2020 – a thought provoking look at the future,* (p 15 et. seqq.) [online]

These two classes and their distinct differences can also be seen in consumer purchasing behaviour. A dual market will emerge which will polarise between discount and luxury goods. Higher earning consumers will concentrate on products with clear functional benefits and added values, whereas inexpensive products with and an identifiable "net value" is offered to the less well-off segment. The difference compared to today is that there will be an increasing number of organic products produced, which will result in more reasonable prices. Therefore, these items will come within the reach of less affluent segments of the population. [1]

### 4.1.4   A Healthy Future

*"A part of our future appears to be evolutionary and unpredictable, and another looks developmental and predictable. Our challenge is to invent the first and discover the second."*          John Smart[2]

Despite the three different approaches and the fact that each future study was evaluated in a different decade or even a different century one can find significant parallels. The Kondratieff theory, "the limits to growth" and the "Horizons 2020" study correlate or provide the basis for one another.

According to Nefiodow, the end of the 4th Kondratieff wave has not only been the alternation between two cycles, but a historic turning point. Until 1970, the expansion of western countries was mainly related to the ability to exploit every new source of energy. In ancient times, humans depended on energy, supplied by wind, fire, wood and water. Later, in times of industrialisation, sources and resources like coal and electricity were discovered. At last raw oil, natural gas and nuclear power were used to satisfy the human demand for energy. Information had always represented a component but it has never been regulatory for development. The massive output of industrial goods, the according energy consumption and the evolving environmental threats have led to a role reversal: Information has become the driving force of growth. At this time, namely the change from an industrial to an information society, Dennis L. Meadows and the "Club of Rome" published their famous study "the limits to growth". [3] They were the firsts to draw public attention to the matter that our finite planet earth cannot bear unlimited substantial and energy-driven development. The workgroup admitted to the fact that the market economy is based on expansion, but they also stated that future-growth should not be based on increasing

---

[1] cp. SIEMENS, *Horizons 2020 – a thought provoking look at the future,* (p 18 et. seqq.) [online]
[2] cp. WIKIPEDIA, *future studies,* [online]
[3] cp. NEFIODOW, L., A., *Der sechste Kondratieff,* (p 10)

energy consumption. One major assumption was that it is vitally important for society to gain some understanding of the causes of growth, the limits to growth, and the behaviour of our socio-economic systems when the limits are reached.[1] At this point, Kondratieff kicks in again, as he implies just two variables to be responsible for further growth: energy and information. Limits combined with the desire for innovation create a constant push and pull situation, building the basis for progress and irreversible trends. If this again is due to information, this implies that the productive and creative handling of information becomes crucial for the economic and social development. In addition to the demand for tangible goods, also social, intellectual, psychological and ecological needs will come to the fore - needs that benefit the individual and therefore favour the holistic approach of health. And also Siemens considers this altered health market as a possible future development, regarding the growing and aging population. The health care sector plays a prominent role in both oppositional scenarios. Siemens predicts, like Kondratieff, a more holistic understanding of the subject. Good health is seen as a consequence of a healthy lifestyle and is considered the number one asset in future economy for the next decades.

According to the World Health Organisation, criteria and preconditions for health can be summarised under the following seven aspects:

- A stable feeling of self-worth
- A positive relation to one's own body
- The ability to build and maintain friendships and social relationships
- An intact environment
- A meaningful job and good working conditions
- Knowledge and access about/to the health care market
- A liveable present and the founded hope for a liveable future[2]

Environmentalism and also the increased interest in social aspects and therefore ethical fashion, is closely related to the predicted key role of the health care market. As already explained before (compare chapter 1.3 Bio-boom – sustainable products for the mass market) the driving force is the individual motivation. For example, the abolition of CFC; the ban on products containing CFC was not done because of human labour of love for our ecology, but because the depletion of the ozone layer would lead to an epidemic of skin-cancer around the globe. Good ecology and stable social circumstances favour the well-being of the individual and can consequently be seen

---

[1] cp. MEADOWS, D., L., et. al., *Wachstum bis zur Katastrophe*, (p12)
[2] cp. NEFIODOW, L., A., *Der sechste Kondratieff*, (p 64)

as a substantial part of the future. In terms of textiles and clothing this would mean that products contributing to water and air pollution, contamination of soil or indefensible working conditions are not acceptable anymore. To expand the health care market, efforts will increasingly focus on developing strategies to satisfy every sense with the idea of wellness. Living space, as well as clothing will be created with ecological textiles, interior equipment and materials.

## 4.2   Interview with Peter Wippermann

Peter Wippermann, CEO of "Trendbüro" Hamburg and Professor for Communication Design at the University of Essen/Germany in Interview about ethical fashion. The interview was done by the author of the present thesis on the 14 June.2007 via telephone in the German language.

Greed of gain, predatory capitalism and being cheap   **Fig. 42: Professor Peter Wippermann**
("Geiz ist geil") is over. Trend researchers agree to economist's views on the future regarding the commitment to ethical aspects. Products, consumers and companies are affected likewise, but are completely different from the lobby of the mid-seventies. The consumer of the future does not just want to be seduced but also redeemed. "A movement without abandonment, but concrete demand to advance innovations." Peter Wippermann on the aspects of "karma capitalism", consumer behaviour and sustainable strategies of the textile and clothing sector:

Q   The 12th annual Trendday, organised by the Trendbüro in Hamburg, was held under the topic of "Karma-Capitalism". You predict the end of competition and the beginning of ethical values. Do you really think that one can change the world with the "right" purchasing decision? P. Wippermann: I think we are living in an economic system that is completely different from the one during industrialisation. Today, it is not just about division of labour, but about teamwork. The lack of interest from past times is fading. In the future consumers will certainly have a growing interest in the production processes.

Q   In their book "The Black Book of Marks – The Dark Side of Global Business" the authors K. Werner and H. Weiss compare the power of consumers in capitalism with voters in democracy. Are people aware of the power they hold and are they willing to make use of it?

P. Wippermann: During the actual process of purchasing, consumers are not conscious of the power they hold. But seen from a greater distance, they are of course aware of the fact that they influence markets with a deliberate purchasing decision.

Q **Does the deliberate purchase decision imply the turning away from "bigger, better, faster" towards old values?** P. Wippermann: Old values are of special interest in a world that is as drastically changing as ours. Retrotrends accompanied the economic sector for years. Trust breeds trust (Vertrauen entsteht durch vertrautes). Values, like politics, religion and family that are not represented by institutions anymore are going to appear more and more in the economic sector.

Q **Despite the rising interest in ethical products, the lion's share of clothing offered on the market is still produced conventionally. Why do most people not care if cheap products are produced at the expense of human rights and environmental standards?** P. Wippermann: Up to now, we have not spent a lot thought on how or by whom our cheap goods were produced. But with regard to globalisation an information flow is created showing production processes that are mainly located in threshold countries. Today, life proceeds at a different pace. One cannot create an ideal world with the help of advertising and marketing anymore, if things look completely different behind the scenes or façade of the advertising. Coca Cola for example was banned by students from "elite universities" in American metropolises, when it became public that they might have been involved in the homicide of a Colombian work's council.

Q **Based loosely on I. Kant, does this mean that consumers are on the way to overcome their inability to speak out?**[1] P. Wippermann: If you understand this term as partnership, and consumers as a part of the production chain rather than uncoupled end-users, the answer would be yes. Like this dialogue, consumption has to be seen as a two-way process.

Q **Do you consider celebrities and the example they are setting as beneficial for the green movement?** P. Wippermann: One has to keep in mind that the generation of the old green movement, when J. Fischer first became minister of the environment, is about to retire soon. The new movement is not addressing itself to politics but to economy.

---

[1] Referring to I. Kant, in this context, the phrase „inability to speak out"has to be seen as the translation of the German word „Mündigkeit". The original question asked in the interview, was: "Frei nach Kant, befinden wir als Konsumenten uns also auf dem Weg zur Mündigkeit?"

Q Does this mean that the new green generation is different from the old one, and in which ways does this fact influence the green attitude? P. Wippermann: I think that the new green generation is completely different from the old one. It is much more erotic because of its close relation to a certain kind of body-aesthetics. Furthermore, it cannot be seen as a movement of abandonment but the concrete demand to advance innovations.

Q Downright competition has started in the United Kingdom. Companies like Tesco, Sainsbury's and Marks & Spencers outgun each other with environmental measures. Are companies abusing the new morality of consumers as a marketing tool? P. Wippermann: No, I would not say so, maybe on an abstract higher level. But at the end of the day, business is about selling. […]

Q Economists say that sustainable consumption will gain more and more importance and that responsible consumers will act as indicators for others. How do you evaluate these statements? P. Wippermann: Well, one should not picture us all becoming "Gutmenschen", tip-toeing around the globe. Consumption without regret means to keep the living standards at today's level for as long as possible. […] Regarding the textile and clothing market, it is going to turn out that the additional benefit will focus more on spiritual values rather than functional ones.

Q Ethical clothing – just a trend that is going to disappear soon? P. Wippermann: Most of the textile companies are just starting to think about ethical clothing. Whereas "Wholefood", America's largest retailer of natural and organic food who now extends business to Europe, has already existed for more than 25 years. This shows that there are companies which internalise ecological thoughts in form of a company philosophy and are successful with this behaviour. Others will just use this strategy as a marketing tool for several years. Then again there will also be people who think that one can do business without social and ecological responsibility. […]

**Professor Peter Wippermann**
Born 1949 in Hamburg, 1984 Art Hamburg - Comunication Design Company; with Jürgen Kaffer, 1990 Chief editor of the Philip Morris' magazine "Übermorgen", 1992 foundation of Trendbüro – monitoring company, together with Matthias Horx, 1993 Professor for Communication design at the University Essen/Germany, 2002 Co-founder of the Lead Academy for media design and marketing.[1]

---

[1] cp. TRENDBUERO, *Peter Wippermann* [online]

Q **Will textile companies, which are not implementing ecological sustainability, be left empty handed?** P. Wippermann: The success of a textile company is definitely not solely based on a sustainable ecological production. Of course, they must also have great designs and competitive prices. Nevertheless, ecological sustainability does represent a crucial factor of the future.

Q **Could we, therefore, be speaking of awareness rather than trend?** P. Wippermann: The term "trend" is quite vague and therefore does allow a number of different interpretations. The Trendbüro deals with this term, as the adaptation strategy of consumers to a changing environment. Experience shows that these strategies last for an average of 10 years, minimum 5 years.

## 4.3 Future Fashion

Our changing environment not only changes the way textiles are produced but also the appearance, i.e. fashion itself. Especially in political and economical unsettled times people are looking instinctively for lasting values. This can also be expressed by clothing, says Elisabeth Hackspiel-Mikosch fashion sociologist and professor at the University of Applied Sciences in Mönchengladbach. Even in recent history one can find examples for the return of forgotten values. In the 30's, for example, women turned literately towards a more classy way of dressing. The global economic crisis and increasing unemployment pushed them back into their traditional role with matching figure hugging feminine dresses. The boyish and emancipated clothing from a decade where women had become employed and more autonomous, gave way to this style. Today, consumers are confused and this raises the desire for a more sensible structure. Consumers want a safer environment and safer colours; moreover they want to get back to a time where they knew where they stood.[1]

This results in a clean chick or as Michael Michalsky one of the most influential contemporary German fashion designers puts it "Conservative is the new exotic". In these times, over-consumption is no longer a signal of success. It does not feel ok to over-expend and to buy unnecessary things when the climate is changing and people at the other end of the world are working for a few cents per hour.

---

[1] GRINGER, J., *Eleganz ist eine Lebenseinstellung*, [online]

### 4.3.1  Zeitgeist

Definitions:

[A trend is…] *the popular trend of a given time[1]*

[Awareness is…] *the compromise of human's perception and cognitive reaction to a condition or event. It does not necessarily imply understanding, just an ability to be conscious of, feel or perceive.* [2]

Reviewing the results of the future studies discussed and the interview with Prof. P. Wippermann, the changes that are happening at the moment can be said to lie somewhere in-between the trend and awareness factors. Assuming that consumers are partially aware of the power they hold, this factor contradicts to the definition of awareness. Then again is the idea of ethical clothing taken beyond the definition of the word trend, as ecology and social balance are said to be substantial parts of 6th Kondratieff wave. A compromise or maybe even an extension of both words in question, lies in the term Zeitgeist. According to the Wikipedia Encyclopaedia, Zeitgeist describes the intellectual and cultural mood of an era. It is the experience of a dominant cultural climate that defines an era in the dialectical progression of people or the world at large.[3]

The changes that were predicted for the future can be translated for fashion as the following:

- Timeless design
- Good karma
- Supreme regionalism
- Individual editions[4]

*Timeless design*

"Fashions fade, style is eternal."                                    Yves Saint Laurent

By consequence of a more and more sustainable lifestyle, the tear and wear society is coming slowly to an end. As consumers will focus more and more on ethical values, they will seek excellence concerning behaviour, process and product. Focus will be laid on quality of fabric and elegance of design – characteristics that extend the life of a garment. As an example; very few people throw away a "Birkin bag" from Hermès, because it has been a timeless piece with great

[1] THE FREE DICTIONARY, *Trend*, [online]
[2] WIKIPEDIA, *Awareness*, [online]
[3] WIKIPEDIA, *Zeitgeist*, [online]
[4] CARLSON D., *David Report, issue 6/March 2007*, [online]

aesthetics since the 1980's. The handbag tells a story and reflects its own time, it brings back some of the best of the old, while continuing to search for the right fashion statement for the women of the present through slight changes. The "Birkin bag" is a luxury good and might therefore not be representative for the mass consumer, but the pattern for timeless design also works on a lower-budget basis. Pants in marlene style, the little black dress, a pencil skirt or even a plain T-shirt have always found their place in modern fashion. Today consumers have difficulties seeing the difference between low price and price-worthiness. The price of a piece of clothing should be calculated according to its lifetime, against the background of real production costs. At first sight the price for a product of good quality might seem high, but if it can be used for a couple of seasons it turns out both, priceworthy and ecologically healthy. Consumers and fashionistas of the future are likely to buy less but better products combined with timeless design. To care about quality is to care about our common future.[1]

*Good karma*

The good karma is influencing fashion in two ways, i.e. behind the scenes but also in the foreground. The conscious consumption in the background will mostly affect the production process. Companies that will focus just on maximising the profits are going to be lost. They will have to become more transparent in order to survive on the market. Environmental and social responsibility, as described in the previous chapters, will not be an added bonus anymore but the basic principle to guarantee success. One has to carefully balance the opinions and wishes of customers, shareholders, employees and society at large.

The second influence will be clearly visible for consumers. Products out of skin, fur and non-ecological cotton and wool will consequently decrease, whereas some products might allow alternative ways of production. Designers like Stella McCartney, Peter Ingwersen – head of the Danish label "Noir", or Katherine Hamnet are the ecological role models to be followed. The second visible characteristic of the conscious consumption is the "do good, and speak about it" theme. Although this might just be a trend for the beginning, it is the exact opposite of former ecological movements.

Fig. 43: L. Cole for K. Hamnett

---

[1] cp. CARLSON D., *David Report, issue 6/ March 2007*, [online]

Responsibility is glamorous and it is not offensive anymore to show off a sustainable lifestyle. Consuming itself is not bad, it is the wrong and excessive consuming that has negative impacts.

*Supreme regionalism*

Brands have always played an important role in the fashion industry. A brand is defined as a name, term, sign, symbol or design intended to identify the goods or services of one seller to differentiate them from those of competitors.[1] This definition implies that a brand is only the consumer's perception. The oldest jeans companies for example had spent over a century advertising their products as symbols of American liberty. As the news broke that Levi Strauss & Co, Guess and the Gap relied on sweatshops for production, it was hard for shoppers to feel free in their jeans. Consumers felt betrayed and the companies did not just suffer a loss of image but also their claimed authenticity was challenged. Brand recognition in the future will probably be as important as today, but the physical delivery is going to make the sale. The products are the true messengers of a brand. Companies which produce in faceless factories in Bangladesh will not be seen as authentic and credible any longer.[2] A lack in credibility might result in image loss today. With society's focus on ethical values and production transparency in demand, in the future companies might be condemned as untrustworthy.

Think globally and act locally could be the future hymn. A new supreme regionalism is able to grow out of this opportunity. Already, some examples for local acting can be found in the textile and clothing industry. The most famous is probably "American Apparel". Dave Charney and his crew have never made a secret about the fact that their clothes are produced in downtown L.A. A rather unusual example for successful local production is the German brand "Haeftling". Prisoners in Berlin's Tegel Prison have been sewing their own uniforms since the 1800s and have sold clothes through a small shop nearby. For years the salescrew avoided the truth about their craftspeople. In 2003, a Berlin advertising company convinced the prison to change its approach. A new Internet domain was launched and shoes, briefcases, trousers and jackets were christened with the word "Haeftling", which means inmate in German. It says on their website: "[The jacket and trouser collections have] simple & honest shapes and are highly convincing. They define themselves according to their utility and durability and not with short-lived fashion trends."[3] Within weeks, after changing their advertising strategy the prison received more than 3,000 orders. After all, when it comes to clothing the "right" bad image can be a good thing.

---

[1] KOTLER, P., et.al., *Principles of Marketing*, (p 819)
[2] cp. CARLSON D., *David Report, issue 6/March 2007*, [online]
[3] cp. HAEFTLING, *Haeftling comes from jail*, [online]

*Individual editions*

We are obliged by globalisation to buy the same products from the same brands all over the world. It does not matter if you live in Berlin, New York or Tokyo. Consumers will find the same brands and shops in local malls and high streets. The trend towards individual editions can be seen as a side effect from timeless quality and supreme regionalism. We are attracted and fascinated by limited editions, because they provide individuality. Flea markets are a good example of this trend. It just feels good to receive compliments for a piece of clothing if one knows that not everyone else in the office or at university will soon have it. In a standardised society, to own something unique makes the owner feel special. The appeal for something individual can once again be seen in the handbag sector. The fact that just a few of the newest "It-bags" are on the market makes fashionistas and celebrities queue for them. This principle was already adopted by smaller labels and taken onto the ethical clothing level by using recycled materials for their products. Martina Zünd, designer of the German label "Zündstoff", creates bags out of old tennis-, squash- and badminton racket covers. They are just currently available on the market but have already become cult items. Not because everybody owns one already, but because they are rare. Due to the enormous demand, the designer cannot get hold of many more of these vintage covers. [1] The bags are not new and, with about a 75€ price tag, not too expensive, but this marketing strategy still works. Once the production material has been changed, there is a sudden surprise of a whiff of exclusiveness.

### 4.3.2 Tomorrow's Style

Not just trend researchers and economists think that the future is going to be about sustainability. Also designers see the potential that comes along with the return to tradition and old values. The magazine "Elle" asked young couturetalents about their opinion on future fashion. The origin of the designer range from Moscow to Hong Kong, but despite their home country they all predict traditional values like character, style and aesthetics.

*"The future comes into being, without lacking tradition."*
<div style="text-align:right">Denis Simachev</div>

*"We believe that a generation is maturing, which rediscovers the art of dressing instead of chasing behind fast fashion trends."*
<div style="text-align:right">Costello Tagliapietra</div>

*"To be really prepared for the future, fashion needs character and a definite theme."*
<div style="text-align:right">Jeremy Laing</div>

---

[1] cp. GLASSMACHER, K., *Kult oder Mode mit Moral?*, (p 47 – 48)

*"Ornaments, excessive patterns and the whole fashionable swank will disappear soon. Fashion is going to be more reasonable, without lacking sex appeal."*

<div align="right">Dorian Ho</div>

*"Classical does not mean glorifying long forgotten styles. It describes elements that survive because they stand the test of time"*

<div align="right">Tonja Zeller</div>

*"Unlike people in the last centuries, we are not wearing complicated robes anymore. Nevertheless, the expression from new clothes should accomplish the same."*

<div align="right">Molly Grad[1]</div>

### 4.3.3 Sustainable-Design

So far, environmentalism has been defined as the regeneration or repair of the environment after the production process. All engineering work has been invested into end-of-pipe techniques. Stand alone, these developments can be seen as an expression of progress, but not the kind of development that tomorrow's industries really need. "End-of-pipe" & "cradle to grave" is going to be substituted by "sustainable-design" and "cradle to cradle".[2] In comparison to the German word design, the English term not only includes the surface and the appearance of a product, but also hidden values like material & process related aspects. The question for future designers, in textile industry as well as in any other economic sector, is: How can design include principles of responsibility? That means, ecological conformity, social compatibility, economic solidarity and a cultural reflection.

The market for these products already exists. America, as the environmental bad guy no.1, created the term LOHAS (Lifestyle of Health and Sustainability) for the new consumer-elite. Alone in the USA, LOHAS already generates a turnover of 230 billion euros, worldwide a turnover of 500 billion is estimated. By now, 50 million American people belong to this movement, in 15 years it is said this will be 219 million.[3] At first view this might appear as hype in marketing business, but the distinct background and the above-mentioned numbers and figures prove critics wrong. There is a steadily increasing group of well-educated and well-funded people, who consequently maintain a healthy and sustainable way of life. The credo is to invest assets and income into products and services that favour the individual demand for health and indulgence, but also benefit one's social and ecological environment. Nevertheless, the new green movement is facing the problem that consumers do not follow through, or are inconsistent, in their environmentally conscience behaviour. They shop, for example, in Bio-supermarkets but drive up

---

[1] cp. ELLE, *Die Zukunft der Mode*, [online]
[2] cp. DALLY, A., *Industrielle Revolution, die zweite*, (p 12)
[3] cp. KERN, J., *Lohas verändern die Märkte*, ( p 23)

with a fancy car that swallows an enormous amount of petrol. These problems have to be overcome, as well as the exclusiveness of the ethical sector for a consumer elite. They should only be seen as the innovators who introduce a sustainable lifestyle and therefore represent the leading milieu to be followed. What kind of consumer groups are already acting sustainably and who is the forerunner in this field can be seen in the following chart:

| Characterisation | Access |
|---|---|
| **Social Leaders** | |
| The self-confident establishment (about 10% of the German population): **Success, a Claim for Exclusiveness** | Realistic, Informative, Ambitious, Reliable Access through: **Ecological exclusiveness** |
| The post-materialistic '68 movement (about 10% of the German population): **Post-materialistic Values, Globalisation Critics, Intellectual Interests** | Realistic, Informative, Ambitious, Funny Access through: **Environmentalism** |
| **Traditional Background** | |
| The middle class intellectuals: (about 5% of the German population): **Conservative, Culture-criticism, Humanistic View on Responsibility, Good Manners** | Realistic, Informative, Ambitious, Reliable Access through: **Natural quality – timeless design** |
| **Mainstream Background** | |
| The modern status-oriented mainstream: (about 16% of the German population): **Seeking for Occupational and Social Establishment and Secure Conditions** | Realistic, Informative, Friendly, Fashionable Access through: **Health** |
| **Hedonistic Background** | |
| The extremely individualistic new bohème (about 7% of the German population): **Spontaneous, Inconsistencies, Self-evidence as a Form of Lifestyle** | Technical, Innovative, Fashionable, Creative, Inventive Access through: **Lifestyle-Avantgarde[1]** |

The bottom line is that sustainable design can be interesting and inviting for every target group on the market. The adoption process is led by the innovators and followed by early adopters as well as the majority of the population. However, sustainable goods have to be communicated adequately and target-group orientated in order to be successful on the market.[2]

---

[1] cp. TISCHNER, U., *Weg von der Müsli-Ästhetik*, ( 105 – 2007)
[2] cp. TISCHNER, U., *Was ist Eco-Design?*, (p 12)

# CON CLUS ION

5

# 5    Conclusion

The approach of the present bachelor thesis was to put "ethical clothing" into the perspective of a time- and dimension related context. Are social and ecological aspects factors that can easily be overlooked by consumers and producers of the textile and clothing sector, or will they even gain importance beyond the next seasons?

I want to start with the summary of the major findings from the single chapters. After showing the close relation between environmental threats and social issues to the textile and clothing sector, the first chapter also reveals the beginning of sustainable behaviour in our society. The Bio boom can be regarded as a signal that the demand for ethical products and the resulting designing principles have already started to influence and innovate the production-, consumption- and business practices of the 21$^{st}$ century. The ethical pressure, in terms of the environmental and social crises, has been more and more transformed into an economic one. The current hype is undeniable and represents the first step towards a new ecology. But the enthusiasm is hindered when looking at chapter two. The major share of textiles and clothing is still produced conventionally and impacts of this sector on ecology and social balance are enormous. Analysis shows that just the goodwill on the part of the producer and consumer for sustainable consumption is not sufficient. Compliance regulations have to be introduced by the government, locally or even nationwide, to make production more transparent and products comparable. This again is not as easy as it might seem. As discussed, governments nationwide have to overcome a lot of barriers to implement reliable regulatory systems. Up to this point the consumer has to take the bulk of the responsibility for his purchasing decisions. In times where a clean conscience represents the added moral value of a piece of clothing, the consumer has to at least put some effort into the identification of labels delivering those benefits. Then again, the fact of consumer accountability does not relieve clothing companies from their obligations. But it makes it harder for black sheep to survive in the market. As shown in chapter three, there are plenty of alternatives for producers and consumers to change processes and practices for the better. Figures reveal that both sides are responsible for half of the energy consumption of a garment throughout the whole textile chain. I started the fourth chapter with the description of three future studies, to give a clear vision of the world we will be dressing up for. Through evaluation and comparison of their main ideas, I came to the conclusion that ethical clothing and sustainability will play a prominent role in our future society. The focus will be put on a new health care market, which provides the framework for a variety of social and ecological aspects, and contributes to the well-being of the individual. The questions for the interview, which followed, with P. Wippermann also originated from the findings of these future studies. The

second half of this chapter then turned its attention to future fashion. I translated predicted changes from a general approach into definite and specific changes for the textile and clothing market. Afterwards, I emphasized these estimations by quoting young couture talents and their view on the future of fashion. Lastly, I closed this chapter with the description of target groups which are already acting in a sustainable way and the assumption that the ethical clothing market can be interesting and inviting for all target groups if the values are adequately and properly communicated.

Throughout the work on this thesis and my research on ecological and social aspects, I discovered the potential that the topic "ethical clothing" holds for discussion and also for active change. There are both critics as well as followers of the green movement and also of ethical fashion.

I am sure that most of the criticism is based on the fact that the last trial for green fashion in the mid seventies disappeared quietly. So why would it be different this time? Why should consumers bother to get all excited when this can also simply be a trend which will soon go out of style? The crucial point that was forgotten during the former green movement was the aspect of fashion in ethical clothing. Because, at the end of the day, we are still talking about styles, fabrics and colour, rather than shapeless unsexy linen sacks. In the past times, ethical clothing was demoted to sole ecological and social aspects. Postulations for regulations were maximised and taken far beyond the doable. Today, claims from the eco-sector are loosened without transforming the ethical approach into a "light" version.

When it comes down to the future, we assume that a definite picture can not be drawn. But as we are still talking about fashion, one has to bear in mind that the ability of the designers to forecast, mainly contributes to the success of a label or its failure. This means that due to the increasing amount of labels and designers focusing on ethical aspects, I could at least say that chances for ethical clothing are good for the seasons to come. Reviewing the outcomes of my work, I would say that the answer to the original question is a compromise of trend and awareness, which can be summarised under the term "Zeitgeist". To me the English translation "spirit of age" represents the compromise between trend and awareness at its best.

*"Brains are made to predict the future. Therefore, we are able to change the direction of our steps in time."* [1]

Daniel C. Dennett

---

[1] cp. HORX, M., *Wie wir leben werden – unsere Zukunft beginnt jetzt*, ( p 341)

# Bibliography

**ADEME- FRENCH ENVIRONMENT AND ENERGY MANAGEMENT AGENCY,**
*An envrionemental product declaration of jeans,* [online] Available from:
www.ademe.fr/internet/eco-jean/, [accessed May 2007]

**ALAM, K., HEARSON, M.,**
*Fashion Victims - The true cost of cheap clothes at Primark, Asda and Tesco, 2006 [online] Available from:*
www.cleanclothes.org/ftp/06-12-Fashion_Victims.pdf, [accessed April 2007]

**ALLWOOD, J., M., LAURSEN, S., E., BOCKEN, N., M., P.,**
*Well dressed? The present and future sustainability of clothing and textiles in the UK,*
[online] Available from: www.ifm.eng.cam.ac.uk,
University of Cambridge Institute for Manufacturing, 2006, [accessed April 2007]

**ANON,** *The Cotton Story,* [online] Available from:
www.hemp-union.karoo.net/main/info/textiles/book2.htm, [accessed April 2007]

**ANON,** *Trigema: kompostierbares T-Shirt,*
Melliand Textilberichte 1-2/2006, Deutscher Fachverlag GmbH (p 84)

**ANON,** *Was man mit einer kWh machen kann?,* [online] Available from:
www.thema-energie.de/article/show_article.cfm?id=511 [accessed April 2007]

**BALZER, M.,**
*Gerechte Kleidung - Fashion Öko Fair Ein Handbuch für Verbraucher,* Hirzel Verlag, Stuttgart, 2000

**BETTER THINKING LTD.,** *Why transparency?,* [online] Available from:
http://www.betterthinking.co.uk/magazine/transparency/docs/editorial.html,
[accessed May 2007]

**BOCK, C.,** *Hinter den Kulissen der Öko-Branche,* [online] Available from:
www.sueddeutsche.de/verlag/artikel/947/108839/ [accessed April 2007]

**BREWARD, C., EICHER, J.,B., MAJOR, J., S., TORTORA, P.,**
*Encylopaedia of Clothing and Fashion,* Thomson Gale, a part of Thomson Corporation
2005, 3rd edition

**BUNDESVERBAND SEKUNDÄRROHSTOFFE & ENTSORGUNG,**
Textilrecycling [online] Available from:www.bvse.de/ [accessed May 2007]

**CARLSON, D.,** *David Report issue 6/ March 2007,* [online] Available from:
www.davidreport.com/ [accessed May 2007]

**CLEAN CLOTHES CAMPAIGN,** [online] Available from:
www.cleanclothes.org/intro.htm, [accessed May 2007]

**COTTON INCORPORATED,** *fast facts cotton,* [online] Available from:
www.cottoninc.com/LifeStyleMonitor/LSMDenim2005/?Pg=3 [accessed May 2007]

**DALLY, A.,** *Industrielle Revolution, die zweite,*
issue 105 - 2007 Politische Ökologie, Oekonom Verlag, München

**DICKERSON, K., G.,**
*Textiles and Apparel in the Global Economy,* Prentice-Hall Inc., 1999, 3rd edition

**DIESEL,** *citation* [online] Available from:
www.stopglobalwarming.org/sgw_partner.asp?668919 [accessed April 2007]

**EBERLE, H., HERMELING, H., HORNBERGER, M., MENZER, D., RING, W.,**
*Clothing Technology,* Verlag Europa-Lehrmittel, 2002, 6th edition

**ELLE,** *Die Zukunft der Mode,* [online] Available from:
www.elle.de/fashion/zukunftsmode/264582.html, [accessed May 2007]

**ENQUETE-KOMISSION,** *Schutz des Menschen und der Umwelt -
Bewertungskriterien und Perspektiven für umweltverträgliche Stoffkreisläufe in der Industriegesellschaft,* 1994,
[online] Available from:www.parlamentsspiegel.de/portal/Parlamentsspiegel_neu/
[accessed April 2007]

**FAIRWEAR** [online] Available from:
www.fairwear.nl/?p=208 [accessed April 2007]

**FEMINISTS AGAINST SWEATSHOPS,** [online] Available from:
www.feminist.org/other/sweatshops/index.html, [accessed April 2007]

**FINN SCOTT, M.,** *The spirit of the girl strikers,* [online] Available from:
www.ashp.cuny.edu/heaven/ftext3.html, [accessed April 2007]

**GILDEDAGE,** *Natural Indigo Jeans,* [online] Available from:
http://www.gildedage.net/craft.html [accessed May 2007]

**GLASSMACHER., K.,** *Kult oder Mode mit Moral?*
TM - Fashion Trend Magazin, May 2007, Branche & Business Fachverlag GmbH

**GRINGER, J.,** *Eleganz ist eine Lebenseinstellung,* [online] Available from:
http://www.taz.de/dx/2004/10/12/a0168.1/text [accessed June 2007]

**HAEFTLING,** *Haeftling comes from jail,* [online] Available from:
www.haeftling.de/ [accessed June 2007]

**HEARSON, M., MAHER, S., FINNEY, C., BURNS, M., MACKAY, J., LIU, S.,
MOORE-BENHAM, B., BARTER, C., BICKNELL, G., COLEMAN,
K., DOMONEY, R.** *Who pays for cheap clothes?, Labour behind the Label,* 2006 [online] Available
from: www.cleanclothes.org/ftp/06-07-who_pays_for_cheap_clothes.pdf [accessed April 2007]

**HESS-NATUR,** *Textillexikon,* [online] Available from:
www.hess-natur.com/redaktion/ueberuns/longlife1.php?[accessed April 2007]

**HORX, M.,** *Wie wir leben werden - unsere Zukunft beginnt jetzt,*
Campus Verlag, Frankfurt/New York, 2nd edition

**HOWIES,** *Are you happy with your wash?* [online] Available from:
www.howies.co.uk/content.php?xId=177&xPg=1 [accessed June 2007]

**HOWIES,** *Plantation denim,* [online] Available from:
www.howies.co.uk/content.php?xId=177&xPg=1 [accessed June 2007]

**HURT, C.,** *The Washington post,* [online] Available from:
www.washingtontimes.com/national/20040805-113236-4189r.htm, [accessed May 2007]

**INGARNELLS, W.,**
*Colour for textiles - a user's handbook,* Society of Dyer's and Colourists, Wales/Cardiff 1993

**INKOTA NETZWERK e.V.** [online] Available from:
www.inkota.de/index.htm?, [accessed May 2007]

**INTERNATIONAL LABOUR OFFICE GENEVA,**
*The end of child labour: within reach, 95th session,* 2006, [online] Available from:
www.ilo.org/dyn/declaris/DECLARATIONWEB.INDEXPAGE [accessed April 2007]

**IVC-E.V.,** *World production 2005,* [online] Available from:
www.ivc-ev.de, [accessed April 2007]

**IVN,** [online] Available from:
www.naturtextil.com, [accessed April 2007]

**KAMPAGNE FÜR SAUBER KLEIDUNG,** [online] Available from:
www.saubere-kleidung.de/2-fs-wir.htm, [accessed May 2007]

**KERN, J.,** *Die Staubschicht wird abgepustet,*
issue 45, 16.11.2006, Textilwirtschaft, Deutscher Fachverlag GmbH, Frankfurt am Main

**KERN, J.,** *LOHAS verändern die Märkte,*
issue 23, 07.06.2007, Textilwirtschaft, Deutscher Fachverlag GmbH, Frankfurt am Main

**KERN, J.,** *Socialwear: Das Interesse wächst,*
issue 52, 29.12.2006, Textilwirtschaft, Deutscher Fachverlag GmbH, Frankfurt am Main

**KLEIN, N.,**
*No logo,* Flamingo, an imprint of HarperCollins Publishers, 2000

**KOOISTRA, K., TERMORSHUIZEN, A.,**
*The sustainability of cotton, consequences for man and environment,* [online] Available from:
www.wur.nl/NR/rdonlyres/24D8701B-F547-4E5B-986E-
1BD07BD2D263/21267/Rapport223binnenWEB.pdf
[accessed April 2007]

**KOTLER, P., ARMSTRONG, G., SAUNDERS, J., WONG, V.,**
*Principles of Marketing,* Pearson Education Limited, 3rd edition 2002

**LABEL-ONLINE,** Available from:
www.label-online.de/ [accessed April 2007]

**LABOUR BEHIND THE LABEL,** *Wearing thin – the state of pay in the fashion industry,*
www.labourbehindthelabel.org/content/view/68/53/ [accessed May 2007]

**LACASSE, K., BAUMANN, W.,**
*Textile Chemicals - Environmental Data and Facts,* Springer-Verlag Berlin Heidelberg, 2004

**LAPPÉ, A.,** *Small planet institute,* [online] Available from:
www.smallplanetinstitute.org/about_us/anna_lappe/, [accessed May 2007]

**LIEBERMANN, S.,** *Korrekte Kleidung,*
NEON issue February 2007, Verlag NEON Magazin GmbH, Hamburg

**MADE-BY,** *What do we do?,* [online] Available from:
http://www.made-by.nl/index.php?lg=en, [accessed June 2007]

**MEADOWS, D., L., NUSSBAU, H., v., RIHACZEK, K., SENGHAAS., D.,**
*Wachstum bis zur Katastrophe? Pro und Contra zum Weltmodell,*
Deutsche Verlags-Anstalt Stuttgart, 1974

**NATIONAL GEOGRAPHIC,** *Gulf of Mexico "Dead Zone" is size of Jew Jersey,* [online]
Available from: www.news.nationalgeographic.com/news/2005/05/0525_050525_deadzone,
[accessed May 2007]

**NEFIODOW, L., A.,**
*Der sechste Kondratieff - Wege zur Produktivität und Vollbeschäftigung im Zeitalter der Innovation,*
Rhein-Sieg-Verlag, Sankt Augustin, 2006, 6th edt.

**NRDENR - NORTH CAROLINA DEPARTMENT OF ENVIRONMENTAL
NATURAL RESOURCES,** *Water efficiency manual,* [online] Available from:
http://www.p2pays.org/ref/01/00692.pdf, [accessed April 2007]

**OEKO-TEX 100,** [online] Available from:
www.oekotex.com, [accessed April 2007]

**OEKO-TEX INTERNATIONAL;** [online] Available from:
www.oeko-tex1000.com, [accessed April 2007]

**PIATSCHECK, N., BINNEBERG, N.,** *Kundenmonitor Socialwear 2006,* [online]
Available from: www.twnetwork.de/recherche/leserservice [accessed April 2007]

**PIATSCHECK, N., BINNEBERG, N.,** *Wann wird Fair Fashion massentauglich?,*
issue 52, 29.12.2006, Textilwirtschaft, Deutscher Fachverlag GmbH, Frankfurt am Main

**RAGALLER, S.,** *New ecology,*
issue 13, 29.03.2007, Textilwirtschaft, Deutscher Fachverlag GmbH, Frankfurt am Main

**ROSENTHAL, E.,** *The New York Times - Can Polyester save the world?* [online] Available from:
www.select.nytimes.com/gst/abstract.html?res=F30717FD3D5B0C768EDDA80894D,
[accessed May 2007]

**ROUETTE, H., K., PETER, M.**
*Grundlagen der Textilveredlung,* Deutscher Fachverlag GmbH, 1989, 13th edition

**SAI, SOCIAL ACCOUNTABILITY INTERNATIONAL,** [online] Available from:
www.sa-intl.org/index.cfm?fuseaction=Page.viewPage&pageId=473, [accessed May 2007]

**SCHINDLER, P., U.,**
*The Jeans Encyclopedia,* Sportswear International

**SEITH, A.,** *Sex, Drugs and Bio-slips,* [online] Available from:
www.spiegel.de/wirtschaft/0,1518,446416,00.html, 14. [accessed April 2007]

**SIEMENS, SCHARIOTH, J., HUBER, M., SCHULZ, K., PALLAS, M.,**
*October 2004, Horizons 2020 - a thought provoking look at the future,* [online] Available from:
http://w3.siemens.de/horizons2020/en/pages/szenario/ueberblick.htm,
[accessed May 2007]

**STEGMAIER, T., WUNDERLICH, W., HAGER, T., SIDDIQUE, A., PLANCK, H.,**
*Entwicklung von Schlichtemitteln auf der Basis von Chitosan,* Melliand Textilberichte 9/2004,
Deutscher Fachverlag GmbH ( p 651 )

**TEXTILES ON LINE,** *Library,* [online] Available from:
www.e4s.org.uk/textilesonline/index.htm [accessed May 2007]

**THE FREE DICTIONARY,** *trend,* [online] Available from:
www.thefreedictionary.com/trend [accessed June 2007]

**TISCHNER, U.,**
*Was ist EcoDesign?,* Verlag form GmbH, Frankfurt am Main, 2000

**TISCHNER, U.,** *Weg von der Müsli-Ästhetik,*
issue 105 - 2007 Politische Ökologie, Oekonom Verlag, München

**TRENDBUERO,** *Peter Wippermann,* [online] Available from:
www.trendbuero.de/index.php? [accessed June 2007]

**TROTTER, C.,** *Dyeing for a change: Current conventions and new futures in the textile industy,* [online]
Available from: www.betterthinking.co.uk/perfect/your_better_thinking_dye_report.pdf,
[accessed May 2007]

**UMWELTBUNDESAMT,** [online] Available from:
www.umweltbundesamt.de/uba-info-daten/daten/wasch/zeichen.htm [accessed April 2007]

**WEISS, H., WERNER,** *Das neue Schwarzbuch Markenfirmen - Die Machenschaften der Weltkonzerne,*
Ullstein Taschenbuch, 2006, 2nd edition

**WIKIPEDIA,** *Aral Sea,* [online] Available from:
www.wikipedia.org/wiki/Aral_Sea, [accessed April 2007]

**WIKIPEDIA,** *Awareness,* [online] Available from:
www.wikipedia.org/wiki/Awareness, [accessed June 2007]

**WIKIPEDIA,** *Cotton,* [online] Available from:
www.wikipedia.org/wiki/Cotton, [accessed April 2007]

**WIKIPEDIA,** *Eutrophication,* [online] Available from:
www.wikipedia.org/wiki/Eutrophication, [accessed April 2007]

**WIKIPEDIA,** *Future energy development,* [online] Available from:
www.wikipedia.org/wiki/future_energy_development, [accessed June 2007]

**WIKIPEDIA,** *Indigo-dye,* [online] Available from:
www.wikipedia.org/wiki/Sweatshop, [accessed April 2007]

**WIKIPEDIA,** *Limits to growth,* [online] Available from:
www.wikipedia.org/wiki/limits_to_growth, [accessed June 2007]

**WIKIPEDIA,** *Sustainability,* [online] Available from:
www.wikipedia.org/wiki/Biodiversity, [accessed April 2007]

**WIKIPEDIA,** *Sweatshop,* [online] Available from:
www.wikipedia.org/wiki/Sweatshop, [accessed April 2007]

**WIKIPEDIA,** *Threats of Biodiversity,* [online] Available from:
www.wikipedia.org/wiki/Biodiversity, [accessed April 2007]

**WIKIPEDIA,** *Zeitgeist,* [online] Available from:
www.wikipedia.org/wiki/Zeitgeist, [accessed June 2007]

**WIKIPEDIA,***future studies,* [online] Available from:
www.wikipedia.org/wiki/future_studies, [accessed June 2007]

**WORLD BANK GROUP,** *Pollution prevention and Abatement Handbook,* [online]
Available from: http://ifcln1.ifc.org/ifcext/enviro.nsf/AttachmentsByTitle/gui_
textiles_WB/$FILE/textile_PPAH.pdf, [accessed May 2007]

**WRIGHT, R. T.,**
*Environmental science, toward a sustainable future,* Pearson Education, Inc., 2005, 9th ed.

## Source of Figures:

**Fig. 1:** DIESEL, *Global warming ready,* [online] Available from: www.diesel.com/# /globalwarming/ [accessed March 2007]

**Fig. 2:** EBERLE, H., HERMELING, H., HORNBERGER, M., MENZER, D. RING, W., *World population and fibre production,* Clothing Technology, (p 9), Verlag Europa-Lehrmittel, 2002, 6th edition

**Fig. 3:** USGS EARTHSHORTS, *The Aral Sea through time,* [online] Available from: www.gly.uga.edu/railsback/CTW2.html [accessed April 2007]

**Fig. 4:** RIVOLI, P., *Textiles and Apparel Exports as a Percent of Manufactures Goods,* The travels of a T-shirt in the global economy, (p 168) John Wiley & Sons, Inc., New Jersey, 2005

**Fig. 5:** ZMP, *Wholefood Sales Figures for the German Market,* [online] Available from: www.oekolandbau.de/haendler/marktinformationen/biomarkt-deutschland/ [accessed April 2007]

**Fig. 6:** HESS-NATUR, [online] Available from: www.hess-natur.de [accessed April 2007]

**Fig. 7:** KUYICHI, [online] Available from: www.kuyichi.com/kuyichi/?page_id=51 [accessed April 2007]

**Fig. 8:** AMERICAN APPAREL, [online] Available from: www.americanapparel.net/wholesaleresources/catalog/ [accessed April 2007]

**Fig. 9:** WIKIPEDIA, *Sustainable Development,* [online] Available from: http://en.wikipedia.org/wiki/Sustainable_development [accessed April 2007]

**Fig. 10:** AUTHOR'S VIEW: *The Textile Chain and its Outcomes*

**Fig. 11:** WRIGHT, R.,T. *Eutrophication,* Environmental science, towards a sustainable future, (p 474) Person Education, Inc, 9th ed., 2005

**Fig. 12:** MAPS GOOGLE, USA, *Mexico,* [online] Available from: www.maps.google.de/, [accessed April 2007]

**Fig. 13:** WRIGHT, R., T. *The Dead Zone,* Environmental science, towards a sustainable future, (474) Person Education, Inc, 9th ed. 2005

**Fig. 14:** RABE, M. *Lecture notes Ecology,* 5th semester, Bachelor Textile & Clothing Management

**Fig. 15:** BALZER, M., *Die zehn häufigsten Berufskrankheiten in den Wirtschaftszweigen Textil, Bekleidung und Leder,* Gerechte Kleidung - Fashion Öko Fair Ein Handbuch für Verbraucher, (p 65) Hirzel Verlag, Hirzel, 2000

**Fig. 16:** **CALIFORNIA MATERIAL EXCHANGE,** *Graders sorting used clothing.* [online] Available from: www.ciwmb.ca.gov/CalMAX/Inserts/2004/Summer/ [accessed April 2007]

**Fig. 17:** **CAMPUS CALIFORNIA TG,** *What happens with clothes?,* [online] Available from: www.cctg.org/gaia_action/what%20happens%20with%20clothes.htm [accessed April 2007]

**Fig. 18:** **PANOS,** *Western Charity undermines African textiles,* [online] Available from: www.newint.org/columns/currents/2004/11/01/uganda/ [accessed April 2007]

**Fig. 19:** **CHILDREN AT WORK,** [online] Available from: www.arlington.k12.va.us /schools/woodlawn/staff/brosiusc/webquests/childlabor/lesson-template1.htm [accessed April 2007]

**Fig. 20:** **DORIGNY, M.,** *Life Magazine Story 1996,* [online] Available from: hwww.business.nmsu.edu/~dboje/nike/pakistan.html, [accessed April 2007]

**Fig. 21:** **UNESCO,** *A new arena for individual initiative,* [online] Available from: www.unesco.org/courier/2000_01/uk/dossier/txt02.htm, [accessed April 2007]

**Fig. 22:** **DER AUER, GRAFIKDIENST,** *Wer verdient beim Schuhwerk auf?,* [online] Available from: www.auergrafik.com/upload/vki0306sportschuh.pdf [accessed April 2007]

**Fig. 23:** **ADBUSTERS,** *Spoof ads,* [online] Available from: www.adbusters.org/spoofads/fashion/nike/, [accessed May 2007]

**Fig. 24:** **DEPARTMENT OF WASHINGTON,** *Niketown,* [online] Available from: www.depts.washington.edu/ccce/assets/jpgs/niketown%202.jpg, [accessed May 2007]

**Fig. 25:** **RIVOLI, P.,** *Textile trade issues assume prime importance in 2004 South Carolina Senate Race,* The travels of a T-shirt in the global economy, (p. 110) John Wiley & Sons, Inc., New Jersey, 2005

**Fig. 26:** **CONFEDERATION OF GERMAN TEXTILE AND FASHION INDUSTRY** *Enterprises and Employes in Germany,* Gesamtverband Textil + Mode (ed.) 2006

**Fig. 27:** **IVN,** *The Quality label Naturtextil,* [online] Available from: www.naturtextil.com/portal/verbraucherinfo_qualitaetszeichen_en,1738,1535.html [accessed May 2007]

**Fig. 28:** **UMWELTBUNDESAMT,** *Euro-flower,* [online] Available from: www.umweltbundesamt.de/uba-info-daten/daten/wasch/zeichen.htm [accessed April 2007]

**Fig. 29:** **OEKO-TEX STANDARD 100,** *Oeko-Tex 100,* [online] Available from: www.oeko-tex.com/OekoTex100_PUBLIC/content5.asp?area=hauptmenue&site [accessed April 2007]

**Fig. 30:** LABEL-ONLINE, *Toxproof*, [online] Available from: ww.label-online.de/index.php/cat/3/lid/269 [accessed April 2007]

**Fig. 31:** FAIRWEAR, *Fair Wear Foundation*, [online] Available from: www.en.fairwear.nl/?p=208 [accessed April 2007]

**Fig. 32:** BALZER, M., *Was versprechen Ökolabels für Textilien?*, Gerechte Kleidung - Fashion Öko Fair Ein Handbuch für Verbraucher, (p 451) Hirzel Verlag, Hirzel, 2000

**Fig. 33:** COTTON INCORPORATED, *Lifestyle Monitor Denim Issue*, [online] Available from: www.cottoninc.com/LifestyleMonitor/LSMDenim2005/?Pg=4 [accessed May 2007]

**Fig. 34:** TREEHUGGER, *Dye me a river*, [online] Available from: www.treehugger.com/files/2007/05/dye_me_a_river.php [accessed May 2007]

**Fig. 35:** LINKE, M., STEGMAIER, T., PLANCK, H., *Development of high-efficient, biodegradable sizing agent based on Chitosan* [online] Available from: www3.itv-denkendorf.de/itv2/downloads/d0004921/WG3BucLinke.pdf [accessed May 2007]

**Fig. 36:** SCHINDLER, P., U., *Acid wash*, The Jeans Encyclopaedia, Sportswear International

**Fig. 37:** SCHINDLER, P., U., *Whiskers wash*, The Jeans Encyclopaedia, Sportswear International

**Fig. 38:** ADEME- FRENCH ENVIRONMENT AND ENERGY MANAGEMENT AGENCY, *An environemental product declaration of jeans*, [online] Available from: www.ademe.fr/internet/eco-jean/, [accessed June 2007]

**Fig. 39:** AUTHOR'S VIEW: The classical waste pyramid

**Fig. 40:** NEFIODOW, L., A., *The Long waves in Economic Life*, Der sechste Kondratieff - Wege zur Produktivität und Vollbeschäftigung im Zeitalter der Innovation, ( p 3) Rhein-Sieg-Verlag, Sankt Augustin, 2006, 6th edt.

**Fig. 41:** WIKIPEDIA, *Dennis L. Meadows*, [online] Available from: www.wikipedia.org/wiki/Dennis_L._Meadows, [accessed May 2007]

**Fig. 42:** TRENDBUERO, *Peter Wippermann*, [online] Available from: www.trendbuero.de/index, [accessed June 2007]

**Fig. 43:** STYLE WILL SAVE US, [online] Available from: www.stylewillsaveus.com/content.asp?contentid=834, [accessed June 2007]

Printed in the United States
139609LV00010B/53/P

9 783836 495486